A Breath of

A BREATH
OF FRESH ÉIRE

OLGA BALAEVA

BEEHIVE

Published 2022 by
Beehive Books
7–8 Lower Abbey Street
Dublin 1, Ireland

info@beehivebooks.ie
www.beehivebooks.ie

Beehive Books is an imprint of Veritas Publications

ISBN 978 1 80097 015 1

10 9 8 7 6 5 4 3 2 1

Designed by Clare Meredith, Beehive Books
Printed in Ireland by Walsh Colour Print, Kerry

*Beehive books are printed on paper made from the wood pulp of managed
forests. For every tree felled, at least one tree is planted, thereby renewing
natural resources.*

For Pádraig
With gratitude for your generosity, help,
and encouragement to follow one's heart.

CONTENTS

PART 4: A PORTRAIT OF DUBLIN AS A GRAND CITY

PART 5: IN THESE STRANGE TIMES

NOTES

WHAT A BREATH OF FRESH ÉIRE CAN DO FOR YOU

Billy Claven suffered as much from his physical disability as from the unkind gossip of the local community. Never mind the limp, they suspected things were not quite right in Billy's head department either: he took to sitting on a stone wall by himself, staring at grazing cows for hours on end.

THE CRIPPLE OF INISHMAAN[1]

There was nothing better for Cathy Earnshaw than to wander the moors – harsh and stormy. What a wild child she was, her maid thought. Sick and heartbroken, nearing the end of her life, desperate for some sort of relief, Cathy threw open her window. The wind was her only medicine and strength, if only she could be 'among the heather on those hills'. Horrified, the maid rushed to close the shutters: 'I won't give you your death of cold'. 'You won't give me a chance of life, you mean'.

WUTHERING HEIGHTS[2]

So hungry for glory, so sure of his excellence and invincibility, Prince Andrei could hardly believe he was wounded as he fell on the ground. The world turned upside down. He heard no battle and felt neither pain nor passion that had been driving him forth only a moment ago. Vulnerable as he was now, Andrei was not anxious to flee the battlefield. All he wanted was to lie on his back and look into the 'lofty, infinite sky'.

WAR AND PEACE[3]

n this book, as I write about becoming soulmates with the Irish landscape, I hope to shed some light on what Billy got out of cow-gazing, Cathy out of breathing the storm, and Andrei out of following the clouds in the grey sky of Austerlitz. Hopefully, their eccentricities will seem less unreasonable by the time you get to the end of this book.

Just like Andrei's attention was diverted from his ambitions to the peace of the sky above, so I have tried to shift the focus of my book from the narrator – how many kilometres she walked, what she ate and who she met on the way – to nature itself and the heritage interwoven with it. What it feels like, what emotions it evokes and how it opens its soul to you if you are willing to bare yours – and what happens when the two meet.

A Breath of Fresh Éire is in a way a personal declaration of love for the Irish natural beauty, which, I find, is a powerful source of inspiration, healing, peace and joy. It lights a flame inside you that does not go out in the wind but grows stronger with every gust. Through this collection of essays, I would like to share this flame, in its various manifestations, in the hope that it will encourage my readers to rediscover Irish nature (and indeed nature in general) as a treasure in its own right rather than a pleasant background; as a source of inner peace and a way to reconnect with the heritage close to one's heart.

ACKNOWLEDGEMENTS

To my Mum – thank you for your unconditional love and support. Thank you for lending a listening ear and for putting up with my Covid longing for places far and wild. Thank you for knowing the difference between Inis Mór, Inis Meáin and Inis Oírr, it means a lot to me! Thank you for holding on to me on stormy Achill, for making it to the top of Croagh Patrick and for being the brave one on the rocky crossing to Skellig Michael. Thank you for worrying, from thousands of miles away, that I would stand too close to the cliff edge at Dún Aonghusa.

Gerry, Heilén, Brian, Sinéad and Clare – thank you for the lovely afternoons in the back garden. It is so peaceful and green that, without a doubt, it deserves a chapter of its own. I am forever grateful for your friendship and your genuine readiness to help, should an emergency arise on the other side of the country. Thank you to Gerry and Brian for resolving my linguistic doubts.

I would like to thank Beehive Books for taking on this project and patiently guiding me through the publication process. Special thanks to Síne, Pamela, Denise, Lir, Clare and the design team as well as well as Leeann Gallagher, my editor, and Natasha Mac a'Bháird, my proofreader. Thanks to photographers John McElroy and Dennis Horgan, and writer Tom Gunning for their endorsements.

Olga – thank you for your genuine interest in my writing, it is especially encouraging when that interest comes from one's literature teacher.

As always, thank you to all my teachers and lecturers who gave me a love for the English language and helped to develop a passion for writing. One needs a lot of inspiration to write in their second language, and that inspiration does not come solely from within. Svetlana, Irina, Tatyana, Lyudmila, Julia – thank you. To my Irish-

language lecturers, Tatyana and Victor – thank you for guiding me through the realm of Irish culture and giving me the tools to further explore it independently.

Thank you to my friends – Lisa, Irina, Julia, Bayveen, Fiona, Lyns, the Conradh gang – for looking out for me. Thank you to Joanne and Catherine for their patience and support.

To all those who have helped me along the way – train and bus drivers, ferry crews, hospitality staff, bike rental services, and, last but not least, my B & B, hotel and Airbnb hosts. I will not be able to name everyone here but I would like to give special thanks to Mairtín agus Cáit ó Inis Mór, Míceal, Helen agus Cáit ó Inis Meáin, agus Máirtín agus a chlann ó Inis Meáin chomh maith. My gratitude and respect go out to those who have provided safe accommodation for me in the last two years; who, without realising it, helped me to give this book the much-needed last push. Sligo, Galway, Mayo, Dublin – you know who you are.

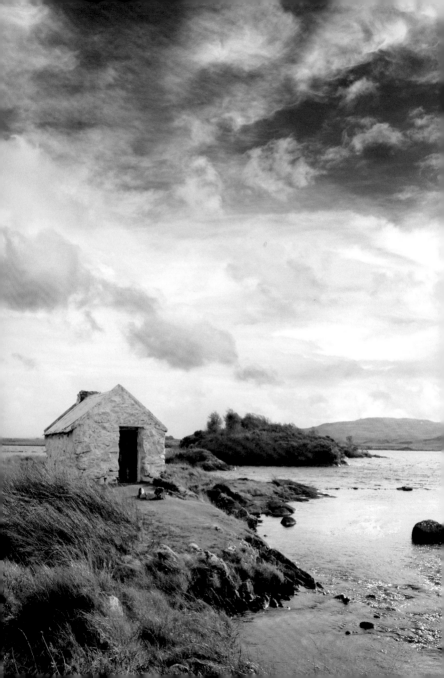

PART 1
THE FLOWERS AND THE GLORY

HEADS AND TAILS
OF IRELAND
THE ROCK OF CASHEL

Once the seat of the kings of Munster, the Rock of Cashel, even in ruins, is a magnificent sight, which over the centuries has preserved an aura of regal power about it. Like a magnet, it attracts the greenest pastures, their lushness untouched by the paleness of the wintry sun; the most poignant Celtic crosses, half-covered in moss, and the restless rooks that circle over the castle, as if spellbound, unable to leave the place.

I love this country's wild beauty, rural quietness, pensive abbeys, buzzing towns and the smiles of its people. All this Irishness, scattered in its various forms across the country, is gathered here at the Rock of Cashel – concentrated and solid. It is Ireland at a glance – ancient and mysterious; torn between the secular and the spiritual; beautiful and yet so down-to-earth, simple and kind.

It already starts to reveal itself on approach to Cashel. It is another few kilometres to the town – too early for speed-limit signs – but the bus suddenly brakes. It must be the local rite of passage. There is only one way to arrive in Cashel – crawling patiently behind a tractor, that symbol of symbols of the good old Midlands.

It is difficult to get lost here. A number of bilingual signposts are scattered around the town, directing visitors to the Rock of Cashel. My eyes slide above the English words to scan the Irish: Carraig Phádraig.[1] Isn't it peculiar how the two rival powers of Ireland – the State and the Church – come together, or maybe clash, in the name of these ancient ruins: English looking after the secular side with Irish adding the spiritual dimension. It is astonishing how much depends on our point of view, and what power of transformation this has. It brings to mind the good old story of a half-full and a half-empty glass; of, as Oscar Wilde put it, seeing either the mud in the gutter or the stars above you; or, more prosaically, in this case, a monument either to the ancient royal power or to the missionary work of St Patrick, who is said to have baptised the first Christian king of Munster here.

Indeed, it is sometimes a case of *either-or* in life, but it is important to remember that it does not always have to be – you can take in the whole signpost in a single glance, and acknowledge the mighty kings of old as well as the fearless faith of St Patrick. The Rock of Cashel. Carraig Phádraig. *Render unto Caesar the things that are Caesar's; and unto God the things that are God's.*

The true beauty of Ireland is that all matters divisive and philosophical – the Church and the State, the North and the South, the yes and the no – are eventually melted in the third dimension of simple humanity.

As I descend the Rock and walk down the main street, people are full of friendly nods and how are yous. It all continues in a gem of a local pub where everyone goes for lunch and is on first-name terms

with the bar staff. It is December, so a proper fire is lit with a generous pile of midland turf. The table by the hearth is free, and, oh a happy coincidence, I spot a plug right next to the crackling flames – now I can enjoy the smell of peat and rest assured that my phone will survive the trip back. As I plug in my mobile, hoping it won't melt, I think how symbolic it all is – symbolic of the skill that the Irish have of balancing the opposites; of keeping traditions alive and well, and, at the same time, adopting things modern and progressive, making sure that the often bland modernity does not destroy the local character. Indeed, *render unto Caesar the things that are Caesar's; and unto God the things that are God's.*

THE ÉIREAD
THE HILL OF TARA

A cattle gate for a castle portal, a blessing of a saint for a frown of a tower guard, a herd of furry cows for royal servants, greeting the weary traveller.

It happens too fast and yet feels so natural. All it takes is just one step off the paved path to let a group of visitors pass; then another step – a sudden gust of wind gives you a slap on the cheek, you turn to face the culprit – and realise that the vast field of Tara is right at your feet.

How simple and unfussy that transition is: from tourist information boards in the car park straight onto the ancient royal ground. There is no pomp, pride or snobbishness here; only simple solemnity which is so easy to miss altogether as *it is faded with years and overgrown with grass.*[2]

The emptiness of the place is truly overpowering. It is all but a vast wild meadow dotted with lanky wheat-like spikes, strong and lush, as far as the eye can see. Once a splendid royal residence – now wiped out

almost without a trace. A carefree breeze is dancing over the stalks; it seems to be laughing, saying *your human glory is vanity, all is vanity*, and on it rustles through the spikes, secretly enjoying its cheekiness.

Tara. A pensive monument to the Ireland that might have been – a kingdom lost, a Troy surrendered,[3] a vacancy long overdue to be filled.

No grand palaces, no thrones, no royal jewellery on display; and yet, Tara is a royal residence where you can get closest to the glorious past. You are free to roam every inch of the kings' dwellings and halls, stand where St Patrick challenged the royal druid, lie on the grass the kings walked on and feel the coolness of the ground in which they may be buried.

Most of Tara is experienced through imagination as you walk around, trying to resurrect the past of the overgrown mounds and hills. The Banquet Hall is much more awake though. As you descend into a trench-like earthwork and walk slowly from one end to the other, you feel that you already *are* in the past, no imagination needed. It is nothing more than a grassy trench to the eye, but it is an ancient road you are walking. Tune your heart into the eery quiet of the place – the people of old are silently present, watching you and letting you pass through their domain. They are not spoilt for visitors as very few walk the full length of the Hall. Most follow the established path down into the trench and up again onto the plain – dipping into the ancient world for a split second, and emerging into reality again, oblivious to what kind of border they have momentarily crossed. The visitors look ahead and trod along, towards the more visible attraction of the coronation stone of Lia Fáil.[4]

The fondness for the Lia Fáil is totally understandable – who wouldn't be tempted to try their luck at the magic stone of destiny? Who doesn't want to stand close to that witness of the legendary kings of old? As I watched one person after another somewhat lazily put their hand on the granite surface, all of them failing to be recognised by the triumphant screech of the Lia Fáil, I couldn't help thinking that it would never be able to compete with the Blarney Stone. There are

usually just a handful of people gathered at the Lia Fáil. Many of them touch it rather reluctantly – as if merely for the sake of ticking the experience off their list. And what do you see in Cork but a mile-long queue of tourists of all ages willing to dangle upside down to reach the Blarney Stone? The gift of the gab turns out to be more attractive than the ancient royal power; *my kingdom for a horse* kind of situation.

If the *royal* power is not on the top of everyone's list, there are still many who are eager to seek favours with the old *magic* powers that managed to survive the destruction of the druids. They fled the centre stage, but never left Tara completely. Beaten down and angry, the fairies huddled themselves up in the short stocky hawthorns right across the field from the Lia Fáil.

Even on a still day, hawthorns are restless: wind comes from nowhere and settles in their dense dark-green crowns. They rustle anxiously as if disturbed by some unseen trouble while the rest of the meadow is still. No wonder hawthorns are traditionally associated with the other world – swishing and trembling, they seem alive, filled with fairy flurry, as if brewing some kind of magic within their crowns, spurred by the colourful ribbons that people tie to the thin gnarled branches.

Keeping a safe distance from the temperamental hawthorns, I head back onto the green expanse of Tara and immerse myself in the carefree fragrance of the summer grass. What a strategic location the Hill of Tara boasts – lush valleys of the Midlands stretch out beyond the horizon. Just think of all those kings and princes and their honourable guests having their famous feasts, gazing over the kingdom, drinking mead and enjoying the magical sunset over the Hill of Tara. Frightfully romantic and too modern a notion, I concede: kings had more urgent matters on their minds – battles to fight, allies to make, fires to keep aflame. And yet, it is hard to believe they totally overlooked the beauty around them, or indeed missed a chance to enjoy it over a chalice or two – weren't they *Irish* kings after all!

FENCE WARS
POWERSCOURT

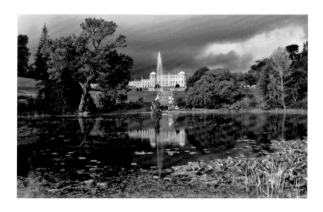

Country estates, so pleasing to the eye, rest heavily on one's shoulders. Stability, comfort and elegance are no easy inheritance. They are the qualities of life to be treasured, cultivated and honoured, never to be cast off – too many a generation has put in hard work to secure them. Hard work that sometimes goes hand in hand with heartbreak, shattered lives and unfairness. Hard work whose fruits are to be respected, enjoyed and developed.

Mighty beeches and oaks, bowing to the world of man-made tranquillity, step aside and form a nicely spaced avenue leading to Powerscourt Estate. Stately, well-fed horses graze the paddock. They are wearing neatly sown blankets to keep off the chill. Calm and cosy, the horses gravitate towards the fence and look out onto the hillside pastures where, under the golden beams of low autumnal sun, sheep are grazing. Tiny white dots – what do they know of comfy blankets?

Free of the honourable burden of hard-earned content, they emanate another kind of stability: timeless and independent of human effort. They graze through bitter winters and clement summers, through joy, love and happinness; through misery, hunger and tears. Life comes and goes but they never stop. They graze while the horses watch wistfully, then yawn, showing their starkly inelegant teeth, and eventually turn away and return to the familiar comfort of the paddock.

Powerscourt roses like to keep closer to home too. Delicate and proud of their weakness, they rightfully take up a good bit of the walled garden. Their intricately curled petals give off a truly charming scent – that of refined parlours, of afternoon tea by a dreamy river, of a beautiful heartbreak from a novel, of a summer evening that makes love so obvious and easy. More adventurous roses grow lanky, stretch their stalks and reach the wall of a stone cottage. Elegance and fragility incarnate, they cling to the roughly clad wall with all the passion that flowers are capable of.

The rustic cottage, no doubt only a humble part of the former estate, welcomes the roses and kindly accepts their affection. Its windows look away from the garden though – onto the distant hills and *green valleys below*.[5] The smoke coming out of the chimney floats leisurely on the breeze through the wilting crowns of kingly beeches, past the iconic green pastures, towards those smaller cottages awkwardly nestled on the side of the mountain, lonely and bare but privileged to be *near to the gate of Heaven*.[6]

Past the regal balustrade and the Triton bathing in its glorious fountain, at the very bottom of the estate grounds, there is another gate – and a fence, to safeguard the fragile beauty of the pleasure gardens. All quiet on that leafy front. The rustic wooden fence is day-dreaming, leisurely turning its gaze from the misty Wicklow hills to the giant pines and Japanese maples of Powerscourt. That grass though, down by the fence, damp, mossy and strewn with fallen leaves – does it not look

a bit messy for an estate lawn? And aren't the trees down here taller and rowdier compared to their orderly counterparts along the alleys? The fence, too deeply engrossed in its dreams, can hardly feel the treacherous shrubbery creep over it, inch by inch, month by month, paving the way for the wild. All quiet on that leafy front, so quiet that this forgetful slumber makes you wonder what kind of ghosts let themselves in unnoticed to roam Powerscourt at night. Come from the hills and fields, they let out a muted howl – and slip through the wooden frames. They swirl around the fountains, making fun of their civil shape. They toss the roses' heads and laugh at their helplessness. They gape into the mansion windows, to see the upmarket shops inside, and, like Cathy and Heathcliff, they mock the order and poshness they find there. They howl again, and at the hint of dawn, retreat into the hills. All quiet on that leafy front. The fence creaks in its sleep and, woken by the chilly dew, dreamily welcomes the golden morning.

When the sun is out, there is no need for fences. The two worlds, still carefully separated from each other, are equally splendid, sparkling like the different facets of the same diamond. For a brief moment (and the sunshine indeed only briefly graces these lands), the tame and the wild are friends, each content with its own beauty, having no need for either rivalry or assertion. They amiably smile at each other across the fence, happy to have such a different neighbour, as they feel that the contrast only highlights their own originality.

Soon, the wind picks up, and a smell of approaching rain is in the air. Gnarled weathered beeches down in the valley start rustling, excited at the brewing storm. But the pines – guards of the fence – stand to attention, determined not to give in to wild emotions. A mist forms in the hills and threatens the gardens but the fence, feeble as it is, miraculously keeps it at bay, and the pale dampness dares not go beyond the paddock. The wind cannot be contained so easily though. As the rain approaches, the vulnerable defences eventually fall: a powerful

gust punches the old fence and swishes through the crowns of the pine guards. Unable to resist anymore, they shake off their aristocratic slumber, stretch their branches and rustle their leaves. Ripples run across the pond, and the Triton frowns as he is caught unawares, and suddenly realises he is unable to control his majestic fountain.

Only the Japanese garden, hidden in a deep hollow, lies low and serene. It has no part in local rivalries. Instead, it preserves that perfect, near-divine balance towards which all states and conditions ultimately gravitate.

Neatly trimmed shrubs, pensive palm trees, gurgling brooks and mossy steps – it feels like descending into an enchanted garden. Splashes of yellow, orange and red – the brightness of Japanese maples is truly dazzling; it feels like ascending into the Garden of Eden full of reddening apples that pose no threat anymore.

A MOUNTAIN RHYME
BENBULBEN

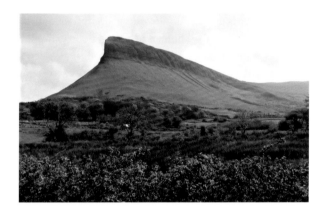

When I first heard about Yeats' attachment to Sligo and the inspiration he took from Benbulben, I have to admit, I all too quickly dismissed it as a romantic cliché or a convenient historical anecdote. How can a mountain – stiff, lifeless rock – inspire the most elegant poetry? I could see the appeal of the never-stopping, ever-changing ocean, or the attraction of mighty trees, whispering their century-old tales. I fully related to the peace and charm of the clear waters of Lough Gill lapping against the isle of Innisfree. But I was unable to accept the idea that a cold surface of a mountain, literally set in stone, was capable of inspiring things live and beautiful. Until I came, I saw – and was conquered.

If travelling from Drumcliff, the first glimpse of Benbulben you get is a view of its graceful, nearly Roman profile: seemingly smooth slopes culminate in a rugged top that curves itself slightly at its highest

point. As you come closer, Benbulben grows tall and majestic, and is now looming over you like a cruise liner docked in a port. Struck by its beauty, you bravely look up – and Benbulben returns your gaze.

The green of the slopes is so intense, it delves deep into your eyes – and yet does them no harm. You feel it oozing its way through your retina – down the blood vessels, into your heart, touching your very soul – and starting to heal it. If you sit down at the foot of Benbulben, with your eyes open as wide as you can, and let it flow into your heart, you will witness a miracle. Barely visible mist snakes around the mountain, as if it is letting out light steam, like a warm body after a long bath. Watch closely: the soft green slopes are alive, Benbulben is breathing – no sign of the dead, invincible coldness of bare rock. The sheep are peacefully grazing, busying around like dozens of Lilliputians, oblivious to the sleeping giant beneath them.

<p style="text-align:center">☙</p>

When I later sat down by Yeats' resting place, and looked across the graveyard, over the valley, at the majestic Benbulben, I knew I had a confession to make: how can your heart *not* be touched by its beauty? How can you *not* want to be buried by its side?

His is a simple grey headstone, easy to miss among the many graves surrounding the old church. Thankfully, there are no tourist signs, glaring 'YEATS' GRAVE' with a thick arrow emphasising the message – he would not have approved. His dying wish was simple: a peaceful place to rest by the side of his beloved Benbulben.

Born in Dublin, Yeats spent quite a lot of his childhood in Sligo. Later in life, he would return here to soak up the tranquillity, find inspiration and write. A Dubliner and a frequenter of London's intellectual circles, I imagine Yeats may have felt he did not fit into the rural west as fully as he wished to, although his heart was yearning for

the peace and beauty of Sligo. What he perhaps did not quite attain in life, he gained in death – now forever united with his land and its people. He has become one of them, neither grander, nor lesser, sharing the same boggy earth. His epitaph seems to confirm that – he is content where he is:

Cast a cold eye

On life, on death.

Horseman, pass by.[7]

What a generous thing for a dead man to say: do not mourn me, go in peace, you have a life to live. I wish we could all be at such ease with death when the time comes – no hope for a slot at the foot of Benbulben though!

THE ARCHITECTURE OF LOVE
KYLEMORE ABBEY

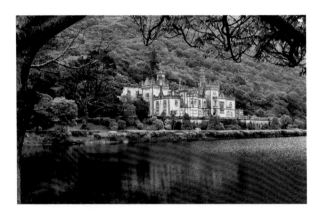

There are places which are meant to impress, and they do exactly that: make you gape with awe and lend themselves to a myriad of selfies.

There are places which take time to be appreciated: they grow like a seed inside you, rooting deeper and deeper with every visit.

There are also places which seem mundane at first and then suddenly but quietly, before you know it, sting you in the very heart. They go right for the middle – nothing more than a needle prick, a tiny hole, a fine incision through which they instantly gain access to your inner self and gently touch your soul. This is the kind of place Kylemore Abbey has become for me.

I had expected a postcard-like location worthy of no more than an hour's visit. Large groups of tourists – some of them too busy posing for selfies to even leave the car park – confirmed my expectations. I

trotted along to the ticket office, joined the queue to get to the abbey grounds, another queue to enter the abbey, visitors swarming all over the hall, my scepticism levels going through the roof.

As I made my way through the rooms and read the story of the owners of Kylemore (which was originally a mansion rather than an abbey), my heart started to melt. I entered the parlour, and the light and contentment that were spilled generously around the room washed over me. I breathed in tension – and exhaled joy. There was no doubt left: that tiny hole in my heart had been made.

There could be no mistake that this parlour had seen happiness so complete, and love so true that decades and decades later it keeps sharing it with visitors. It is not hard to imagine pleasant Victorian evenings when the blissfully married owners, Mitchell and Margaret Henry, were snugly yet gracefully seated on those couches, lights on, the dark hills of Connemara stooping to look into the bay window, guests chattering away, the hosts exchanging loving glances, delighted to be sharing this fairy-tale castle with each other.

Mitchell cherished his wife so much that he wanted to recreate paradise on earth for her. The dream came true, and Kylemore Abbey arose. A place built and designed for love and life through love. All things on earth eventually pass though, and that paradise of love came to an end when Margaret died at the age of forty-five. Grief-stricken, Mitchell must have been unable to say goodbye to her, so her body was embalmed and placed in a tomb in the woods, a short walk from the mansion. It is a quiet place off the main path, nestled under a gigantic tree. Thirty-six years later, Mitchell joined his wife.

He also built a miniature church in her memory where every detail speaks of all things that Margaret must have been for him: feminine elegance, lightness, meekness, loving comfort and warmth. The gothic gargoyles over the church door are no gargoyles but beautiful angels. Inside, the columns that hold the vaults are slim, made of four

pastel-coloured types of marble: green from Connaught, pink from Munster, black from Leinster and grey from Ulster. What a touching gesture it is – to gather marble from the four provinces of Ireland to lay at the feet of one's beloved.

The lighting in the church is soft and warm, and a quiet choir recording is playing. *This is a place of prayer, please be quiet,* warns a sign by the door. They are not much help, those signs – you would usually get some kind of a humming noise anyway as people would start whispering to each other, walking around, taking pictures, being touristy. The sign *does* work in this church though. Or rather not the sign itself but the reverent quietness of the place and the eternal grieving for Margaret – not hopeless grieving though but the grieving through which true love shines and over which it has triumphed.

I slide into one of the pews and watch the church work miracles: visitors enter, their movements jerky and anxious; they make their first steps down the aisle and, as they move, they gradually grow quieter and more thoughtful. By the time they reach the altar, they are properly aligned with the all-encompassing pensive mood of the place.

In fact, the whole Kylemore estate is a wonder. An Englishman's fairy-tale mansion of exquisite architecture placed right in the heart of desolate and harsh Connemara – isn't it the cruelest of mockeries? It could easily have been. Instead, tender affection for his spouse and care for the local people, which Mitchell made the foundation of his project, turned it into a haven of peace in the middle of windswept wilderness. Even stern Connemara bows its twelve Bens to this monument of love. They surround and protect the abbey, sure to stand guard over the estate for years to come.

AWE AND PEACE
CONNEMARA

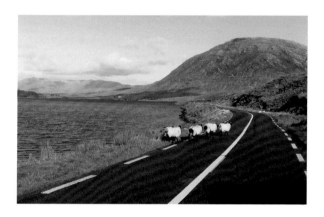

'Oh my God, where are the rolling green hills?' my fellow passenger, a tourist, said, a note of annoyance and disappointment in her voice. She sounded like a customer who was served a pale likeness of what had been promised in the advert. The Aran ferry shuttle was stubbornly curving its way through the bogland, determined to get us to the port of Ros a Mhíl on time. 'And the animals,' the lady nodded at the local donkeys, 'they look as if they were all dying' – more disgust than disappointment in her voice now. Flat, desolate and rugged, and so desperately misunderstood – I felt hurt for my unrivalledly beautiful and infinitely wild Connemara. Hurt but serene as I remembered my own journey – from initial alienation to becoming soulmates.

It was a bleak December day, a quick trip to Clifden to do some field work for my research project. As the intercity bus from Galway

burrowed further and further into the empty brown spaces of wintry Connemara, I squeezed deeper and deeper into my seat. I could physically sense pure wilderness and hostility leaking through the windows, the mountains closing in on us, frowning at the bus and its passengers who dared disturb them. I was glad when my two hours of data collection in Clifden were over. I jumped back into the safety of the intercity which hurried away from that impressive (of course!) but threatening and dreary place, my mood lifting by the minute as Galway suburbs came into view.

I dared return only a few years later, having settled in the country and gotten used to its ways. Still, it was with a faint heart that I boarded that same intercity one Easter weekend. The day was brighter this time, and I was more mature, so it did not take long for me to open up to the stern beauty of Connemara. The mountains themselves, as we zipped by, seemed to be nodding approvingly, stepping aside to let the bus slide safely into Clifden.

Connemara has to be walked – along its bog roads, aiming for the inky mountain caps towering in the distance. Driving through it in the comfort of a well-heated car and jumping out for a few Insta-friendly shots will not do. Let your feet tread every inch of its desolate brown land and work through every peat hillock that bars your way. How else will you sense the ancient power of the glaciers that carved the well-hidden valleys; how else will you know the heavenly purity reflected in the pristine lakes; how else will you feel the heartbreak of the generations past, who travelled these roads in times of hunger and hardship?

Never fully tamed by humans, Connemara has lent its animals that touch of special independence which cats have – independence bordering on boldness. As I was burrowing deeper into the lonesome expanse of Derrigimlagh bog, I realised I was far from alone and possibly not so welcome: a good few sheep appeared out of nowhere,

lining the path, staring. Another one, a chancer of a sheep, was walking towards me, swinging from side to side, looking overly pleased with its good self. Cool as a cucumber that sheep was, not even thinking of stepping aside or slowing down a bit – holding it till the very last moment. As it drew level with me, its nerves gave in eventually, and it awkwardly jumped into the roadside ditch. A moment later the sheep reemerged, still full of itself, back on track, pretending nothing had happened.

Another sheep played the same game on the main road – indeed, why wouldn't you feel an urgent need to cross and, most importantly, pause in the middle of the road, to gain that extra respect? Sure, what choice have they got but to wait – three cars and me on a bike – a nicely sized traffic jam for a modest boreen.

Not everyone gets off so lightly in this part of the world though. The number of dead animals I came across in Connemara was striking: a badger by the side of the road; two lambs in the fields; a blue tit I had to cycle over to avoid oncoming traffic (the tit was already dead by then, in case you were wondering); a seagull under a tourist information sign, its huge yellow legs sticking up into the air; and something like a pine marten, flattened into an unrecognisable furry shape by passing cars. I am under no illusion but that the images my descriptions evoke are pretty grim. Yet, in a place so pristine and wild, the presence of death feels natural: it is in fact an integral part of life, the next logical step that has to be taken. We often choose to forget about death, but here in the depths of Connemara, it jumps at us – raw and real – a reminder that it is there and it is going to catch up with us all in some shape or form, whether on a quiet country road, in a bustling city or out at sea.

As it happens, one of my visits to Connemara brought me a bit closer to death than poor sweet lambs and runover tits. The news of my granddad-in-law's passing reached me as I was cycling the

Ballyconneely loop. Devastated, I really had to hold myself together to make it back to Clifden with no accidents.

Some would say Connemara's forbidding terrain can easily drive happy people into depression, not to mention someone who is distressed. However, I felt quite the opposite – it was a blessing to receive the sad news here and not in buzzing Dublin or picturesque Wicklow. The windswept landscape of Connemara neither consoles you nor offers a distraction from grief. It does something much better – it tunes in to the way you are feeling and goes through that pain with you, eventually healing it and bringing peace. And I find that peace is often more relieving than joy.

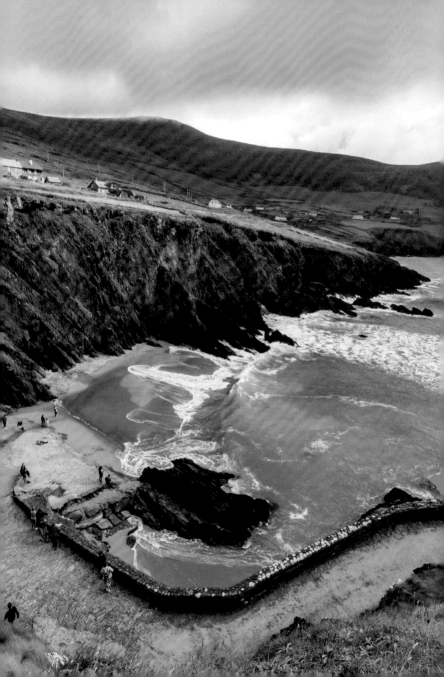

PART 2
THE WILD ATLANTIC SPRAY

ONE KERRY TO RULE THEM ALL
KILLARNEY: THERE – AND BACK AGAIN

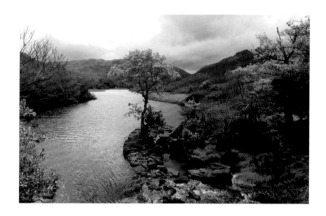

Atown of thousands of welcomes – Killarney greets everyone with an open heart. It generously splashes the colourful beauty of its flower baskets, shares the neatness of its streets and throws open the doors of its rose-entwined cottages. It sends quaint horse carriages trundling around the park grounds and rolls out perfectly groomed lawns on the approach to Muckross House. Killarney works hard to look effortlessly chic – even Brendan the Navigator on the icon in St Mary's Cathedral makes light of his arduous journey, balancing a boat and a whale in one hand while holding an open book with the other.

Those carefree Killarney summers – laid-back atmosphere, shops open late, holidaymaker couples strolling up and down cosy little streets, making their way to restaurants and pubs; then walking back, breathing in that warm summer evening, not caring about the

day to come as the day to come will be another day of their holiday – slow, relaxed and filled with the peaceful beauty of Killarney's lakes and hills.

Just as there is hard work hiding behind the town's elegance that needs to be recognised, so there is also a wild, untamed power lurking on Killarney's pretty doorstep, that needs to be reckoned with. It is closer than it feels: it does not take more than literally a step off the beaten track, a scrape on the surface, to experience it in all its might.

At Dinis Cottage, I take a winding footpath running into the woods. Bright green moss that covers the ground, the roots and the tree trunks makes the path look soft, safe and inviting. It takes me to the Old Weir Bridge where time stands still while Purple Mountain watches over the valley. The silence is so intense and full of invisible wild presence that it is hard to stay at the bridge for long, face to face with it, holding its gaze. It turns out awe and peace do not go hand in hand. Reluctantly, I look away and hurry back across the bridge. A sudden gust of wind swoops over the wood, and the quiet fairy-tale trees turn into powerful giants, shaking their crowns as if threatening me, the intruder, who dared go off route and lay her eyes upon the unattainable beauty that lies beyond the Old Weir Bridge. Like a lost, scared child, determined to be brave but feeling unbearably small and totally unable to counterbalance the rebelling nature, I eventually lose heart and break into a run, hopping faster and faster over the roots, getting closer and closer to the safety of Dinis Cottage.

I smile as I continue on the familiar loop around Muckross Lake. This is the bridge where Mum and I waited for the rain to stop and, giddy with hazy sunshine, took a crazy selfie of our wet selves. Over there is the path to the lake shore where we debated whether there were laws against swimming in the national park. And, eventually, Torc Waterfall where Mum confessed she disliked waterfalls simply because they were admired by so many. I take a snap at the Meeting of

the Waters – she will like this one, it will remind her of how we nearly fell into the water on this very spot.

What a strange feeling it is – to be following the same route, admiring the same views, taking the same pictures with the only difference of having no company this time.

It makes me think that, truly, we all need those wistful lonely experiences. They are a gentle nudge, a mild echo of the time when it is more than just circumstances that will make us continue the same journey without our loved ones – learning to walk the same route alone, and to have courage to get on with life when so much has to be left behind.

THE FELLOWSHIP OF THE GREEN — AND YELLOW

VALENTIA

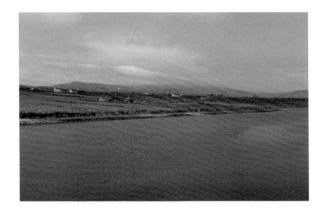

We all have to learn to step outside our comfort zone, so the next morning, still a bit pensive after my excursion to the Old Weir Bridge, I leave the comforting bosom of Killarney and set out to dig deeper into the Kingdom.[1]

Alert and eager to take things in, as we all are on a new venture, I follow the landscape closely, my linguistic antennae sticking out nice and high. Hurrying towards Caherciveen, the bus passes one of the most curiously named villages I have ever heard of: Letter. Who on earth would give a place such a name? The infamous nineteenth-century surveyors, most likely.[2] The original name is An Leitir (as in Letterkenny in Donegal), which means *hillside,* but the surveyors could not be getting into such intricacies. Just another village,

nothing to write home about (nothing but a letter maybe). I later found out that there were at least fifteen Letters scattered around Ireland: letter-writing was popular in the 1800s after all.

My final destination is Valentia. Sounds a bit suspicious. Images of white-washed houses, ripe oranges and the sun splitting the stones pop into my head but I am sure there is a catch. However Spanish *Valentia* might sound, the name comes from Irish and is another example of those awkward and not very thoughtful translations. The island of Valentia on one side and Portmagee hills on the other form a narrow entrance from the open Atlantic into a safe harbour, like the mouth of a giant river. Its name in Irish is Béal Inse, 'the mouth of the island', but sure, it sounds like *Valentia*, never mind that Spain is a thousand miles away.[3] The weather is not always kind in Kerry so I think it is actually nice to have a place with a warm, sunny name and to pretend we are all roasting, having a whale of a summer, just the way people sit out in cafés and bars in early spring – look at us, we are so continental – never mind those heaters above our heads making the experience bearable.

There is no need for pretence just yet though. Kerry's flag – the cheerful green and yellow – is flown proud and high in the summer. The hills are intensely green. They are so lush – and *lush* is the word for the hills of Kerry – that I feel a physical need to scream or squeeze someone but, thankfully, no one is around on that country road on Valentia, and I somehow manage to keep my mouth shut. Scattered around the hills and valleys are buttercups with thick, juicy petals – as yellow as they can get. They are fortified by remnants of gorse flowers, which spread that sweet smell that makes you drowsy and lures you into lying down in a field and falling sleep – just like the poppies in *The Wizard of Oz*. I do respect Kerry's choice of colours and see where they are coming from but on those bright days I often think that green and blue rather than green and yellow are *the* colours Kerry should have adopted. The flowers will be gone but whenever

the sun is out, there is nothing more striking and joyful than the azure sky against perfectly green hills.

In the afternoon, the heat gets so intense that a mist comes down and curls around the hilltops. Walking from Portmagee to Valentia over the bridge, looking at those hazy slopes across the water, I feel as if I were crossing into Tír na nÓg, surreal and close, yet slipping away as I try to come closer. It nearly makes me commit linguistic heresy as I start wondering about a possible hidden connection between the words *mist* and *mystery*.

As the dusk settles in, the breeze dies down and people, tired of the intense heat of the day, snuggle on the sofas in their houses. A proper thick cloud descends onto the hills of Valentia. It is heavy and light at the same time, pierced with hues of pink and purple from the setting sun, making the island look otherworldly once again.

THE TWO ROCKS
SKELLIG MICHAEL

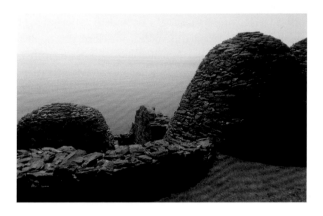

A s it turned out, Valentia was only a taster of all things mystical (or shall I say *mist*-ical?), a preparation course of sorts for a trip to Skellig Michael.

We set out early, all tense and expectant, a bit irritated by the delay caused by two fellow passengers. The boat is small, and social tension is bound to take root anyway, not to mention the poor souls feeling super-awkward about their faux pas earlier in the morning. If only we could all have a drink to take the edge off things. Prosecco, preferably. What we get is very similar but marine style. The skipper spots a pod of dolphins and starts following them. Two, four, ten, twelve of them pop up here and there like champagne corks, having the bubbliest effect possible on everyone onboard. The crystal clear shimmering Atlantic and those graceful creatures instantly turn the journey into a feast of pure joy. *A pod of dolphins*, what a suitable expression, I

think, as I imagine peas breaking a pod and shooting out of it, like dolphins slicing through the water, up into the air and back into the blue depths of the ocean.

It is a fine morning, and when I say *fine* I mean proper fine, not modest Irish-style fine: blue sky with not a single cloud. The world looks clear, straightforward and real. We seem to have passed the dolphin patch and are now back to being normal grown-ups, sitting in an orderly way on our benches. As the boat is steering towards the Skellig, it is keeping left, so the rock appears just to the right of the bow: rising in the middle of the ocean, enveloped in a mist of mildest hues of pink and blue. The mist, as well as the rock itself, looks otherworldly and strikes a sharp contrast with the cloudless day. The nearer we get to the Skellig, the more it feels as if we are leaving the earthly world to be transported to some in-between space, a purgatory of sorts; as if we are travelling on Kharon's boat, dare I say, save for the abundance of light around us.

Skellig Beag[4] eventually comes into view as well, but I do not really take to it. Despite its name, it does not look small to me at all. It is shaped like one of those back teeth with a dip in the middle, whereas Skellig Michael is more of a correctly shaped cone. It nearly looks smaller compared to the sprawling tooth of Skellig Beag. Instead of the bluish pink mist of Skellig Michael, Skellig Beag is surrounded by a white cloud of thousands of gannets, screaming as they circle the rock. It sends me straight back to my childhood and *Mio, My Son* by Astrid Lindgren, read out loud to me by my Mum. As Mio arrives to fight the evil Sir Kato, he sees a lake whose dark waves are lapping against the rock of his enemy's castle. A flock of seagulls is circling over the water: they are no ordinary birds but boys and girls who were once kidnapped by Sir Kato. The gannets of Skellig Beag make a much more cheerful but still a slightly unsettling sight. I find myself imagining that these birds are the ones who lived long before us; the

souls brought here hundreds and thousands of years ago to pass their eternity in the middle of the ocean. Murky thoughts creep into my mind as I breathe in the cool, dank air that the breeze brings from the weather-beaten crags of Skellig Beag. Those gannet cries, muted by the distance, are actually quite mesmerising and do not sound that desperate after all. Wouldn't the dead peace of purgatory, I wonder, be more desirable a state than the dazzling jubilation of paradise?

As we dock at Skellig Michael and I make my way up the famous steps, I know you cannot beat paradise. The rock, so bare and forbidding from a distance, is actually teeming with life. Numerous green patches are covered with white flowers, and, warmed up by the mercilessly shining sun, they give off a sweet, earthy smell which makes me a bit dizzy. As I look closely at the grass, I spot puffins busying around, pecking at the ground. How tiny they are, how sweet!

I imagined puffins to be the size of a seagull: stubborn hungry seabirds, proud and well aware of their beautiful plumage. In real life, they are small enough to be cupped in one's hands; modest and shy, they mind their own business, walking around and then quietly disappearing into their burrows.

Puffins are equally adorable in the air. They take off clumsily and flap their short wings very earnestly and very frequently to keep their fat little bodies going. They do not draw in their feet at all when they fly so you can clearly see pairs of broad black flippers dangling in the air. As I climb the Skellig, I glance up from time to time, to see yet another puffin approach the rock, bumpy and hesitant in its descent like one of those paper airplanes which do not fly distances longer than a room (puffins do though but I struggle to imagine how they manage to).

Puffins of Skellig Michael are not just cute: they lack a fear of humans. It makes me think of that primal harmony about which I read on the first pages of my illustrated *Bible for Children*. I still

remember those bright jubilant pictures of the newly born world where no one harmed anyone and no one was afraid or suspicious of each other simply because they knew no evil – and that was the essence of paradise.

The monks of the Skellig, already well aware of the evil, must have been seeking to escape it, to recreate that primal harmony, that *paradise lost*. St Brendan the Navigator had been looking for the Isle of the Blessed for seven years. His disciple St Fionán, it seems to me, fully completed the quest of his mentor when he picked Skellig Michael for his monastery. The serenity of the place is unbelievable. What one expects is lifeless rain-washed surface, constant wind and deadly chill at the top of a rock in the middle of the North Atlantic. What one finds is a safe harbour, a cosy beehive monastery, a mild breeze and warm air rising off the ground. Down by the very wall of the monastery, there is a fenced lot with crooked stone crosses, facing the open ocean. The monks who once found this paradise on earth are laid to rest here. All they had longed for was peace – ironically, they ended up with tourists walking around their graves, taking pictures. Some less considerate visitors might even stick their faces between the crosses for that cool photo, or simply sit on the graves. This must be the monks' last challenge, the post-mortem test of their patience and humility. I am sure they will pass it, as they know that the peace of the place is beyond all earthly cares, and come autumn, they will get the rock back – all to themselves, until next spring.

THE RETURN OF THE WILD
THE GREAT BLASKET

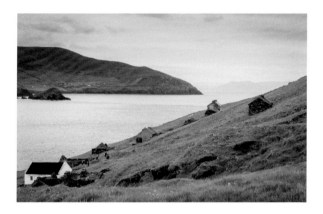

Some thirty-odd kilometres north of Skellig Michael lies another island: the famous Great Blasket. The same waves crash against its cliffs, the same wind batters it; it poses similar hardships and, one would think, offers the same invigorating serenity.

Abandoned about eight hundred years ago, Skellig Michael is still full of life. Never mind flowers and birds, there is a sense of activity about the place, as if human energy was still being expended there, as if the monks' legacy of hard work lived on, hovering over the rock but unable to take any visible form.

As much as the Skellig is about proactive presence, the Great Blasket has a distinct aura of dispassionate absence about it. Still inhabited some seventy years ago, the island feels as devoid of domesticity as if it had known none at all. All traces of life have been fully erased, all too quickly; uprooted mercilessly as if to prevent any

hesitation, or temptation to repair and heal. Roofless cottages are split open, like a broken heart that has never been put together again to make sure that nothing else can break it and no sorrow can scar it.

The very shape of the Great Blasket is fractured and irregular as if meant to reflect its troubled fate. It makes me think of an elephant kneeling in the ocean that has turned out to be too shallow for its mountainous body. At first glance, the once inhabited eastern slope seems to be all that there is to the island. In fact, it is but the backside of the beast while the main land mass is hidden beyond a ridge that runs like a giant spine lengthwise across the island. Over the ridge lies a vast expanse, never tamed by the islanders. Broad, smooth slopes sweep down to the sea while the spine winds its way westwards from headland to headland before it culminates at the highest point of An Cró Mór.

Walking that terra incognita is a somewhat cosmic experience. The feeble cliff path dodders westwards until there comes a point when it turns a corner and the mainland disappears from sight. You know it is only hiding behind the ridge but at the same time you could not feel further away from the world. It is liberating and scary, beautiful and treacherous, nourishing and lonely at the same time. I wonder if these emotions come close to what the islanders felt, torn between the irresistible pull of the place and its cruel emptiness that seeks to reject human life.

Today, the colours are so mild, the breeze is so warm, Inis Tuaisceart[5] sleeps so peacefully across the water that it is hard to believe this island has claimed lives and eventually pitilessly ousted its inhabitants. The Great Blasket is no elephant after all but a giant boa constrictor that has swallowed the beast and taken its form. It slurped the people who fell off its cliffs or crashed their boats against its crags; it devoured all joy, troubles, love, pain, grief, goodwill and ingenuity of generations who used to live here. It did not take the

constrictor long to digest it all and spit out a tabula rasa of oblivious wilderness. The hard-worked fields have overgrown, local donkeys have turned into tiny furry mammoths that hardly recognise people, and a large colony of seals has fully established itself on An Trá Bhán.[6] You could even say the island is finally at peace, resting after a turbulent feast. It is a capricious kind of calm though, the calm that one should handle gently and tread through carefully, like tourists stealthily approaching the seals on An Trá Bhán, eager to witness the wilderness come so near and settle so fully in place of human life.

The seals are protective of their personal space, though, and will not tolerate close inspection. Fungi the Dingle Dolphin is more generous in that regard. As we return from the Great Blasket, Fungi gladly welcomes the boat back to the harbour and throws open the doors of the animal kingdom for us. His presence works wonders on everyone: the crew call him a blessing and the passengers happily plunge into the world of unsuppressed excitement and carefree laughter, forgetting their tension and awkwardness.

Sadly, we have all tasted the ugly side of life, and are now drawn to come close to a living being that is not corrupted by it; a creature that is not even aware of evil, but is, in fact, beyond it. We instinctively feel that such an encounter could heal our souls, and, if only for a moment, bring us back to the life that knows no shadows. We rush to the railings to catch a glimpse of Fungi's arched back, pointy, shiny fin, and, if we are lucky, his roundy snout.

Everything about him felt effortless, graceful and smooth – until you accidentally met his eye. Fungi would never avert his gaze but would always look back carefully and earnestly. I will never forget that startling contrast between the glossy dolphin and his old, thoughtful, pensive eyes. Maybe he did know evil after all, or loneliness, or pain. Or perhaps he was just feeling sorry for us – clowns on a boat that make a mess of their lives and come running to him to be healed.

Back on dry land, I walk the harbour as the sun disappears behind the hills. It is chilly and breezy for a summer's evening. I am about to turn back when I spot a grey seal pup, curled on the pebbles. So lonely, cold and helpless; its cute fluffy coat is no use anymore. A sad little snout, how scared it must have been. A tiny bundle of life ruthlessly crushed and thrown away – unwanted and abandoned. Another prey of the insatiable constrictor. I wonder if we will ever figure out how to reconcile the beauty and cruelty of the wild? Until then, sleep tight, little one.

THROUGH LOVE-TINTED GLASSES
GALWAY CITY

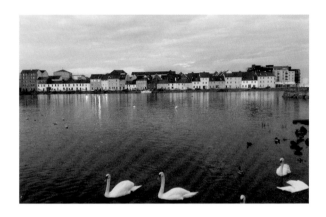

When I taught English, I made sure my students got plenty of opportunities to practise the language. 'What did you do at the weekend?' – here you go, use your past tenses to your heart's content! Some students stayed in Dublin, others went on day trips: 'I was in Galway, I didn't like it.' However grammatically perfect the narrative was, a secret angry bird would stir uncomfortably deep inside me. *Didn't like Galway* – these words do not belong together (I praised the students for their stories, of course). Every 'I didn't like Galway' – alas, there were a few – was like a slap on the cheek; and every slap made me think: why *do* I like Galway so much?

I like that salty breeze filled with seaweed aromas; Eyre Square at Christmas, dotted with festive food stands and fairy lights; lunches at the Skeff with its endless levels and snugs; Shop Street with buskers and dancers; the dignified quietness of St Nicholas's; the bustle of the

market, full of stuff you will never get in Dublin; Claddagh rings all over the place; cosy pubs with decent turf fires in winter; bits of Irish overheard in the streets; the good-humoured Galwegians; fishing boats by the Corrib; an odd hooker gracing Claddagh with its presence; random palm trees still keeping up appearances despite the wind and the rain; above all, I love the Atlantic that stretches along the Salthill promenade – beautiful, crystal clear, unpredictable, sometimes green, sometimes strikingly azure, often grey and infallibly invigorating.

My refuge, my getaway, my go-to, where that invisible hand of sorrow and anxiety eases its grip. The dark may survive the mayhem of Shop Street but will inevitably be swept away by the treacherous waters of the Corrib. Mercilessly and jubilantly it picks up the offender, drowning it in its powerful waves, dancing its victorious dance, as it hurries down the stream, impatient to join the mighty Atlantic.

On a sunny day, the Corrib goes pure blue. When the tide is out, the river retreats, baring its rocks covered in lime green seaweed. It grows so shallow that swans can reach its very bottom, and they do so, floating heads down, like graceful question marks, asking the Corrib for food. The blue of the water against the green of the rocks, spiced up by the yellow and red of the terraced houses across the stream, can breathe life into a wounded soul and ease any sorrow that roams one's heart. Take a deep breath and cast your glance as broadly as you can, take it all in, in one go – the whole place is yours and within you – the Corrib, the boats bobbing on its choppy waters, the swans, the houses, the gulls. Hold still as this scene takes root and gradually expands within your chest until you feel you have become a natural and for now inseparable part of it, like that last missing bit of a jigsaw that has finally fallen into place.

∽

As I continue past the Corrib and on to the Salthill promenade, the remaining stress, troubles and grief evaporate into the thick, salty air.

Today Galway Bay is neither sparkling under the rays of the sun, nor is it raging with all its Atlantic fury. It is one of those soft spring days which are forecast as sunny but inevitably turn out greyish with the sun shining through a layer of flat, boring-looking clouds. No hope for a glimpse of the classic green Atlantic.

The sharp iodic smell of seaweed at low tide fills the air. With hardly any breeze, waves are softly breaking against the sand, lulling you to sleep, making you relax your vigilance as they stealthily gain speed and now roll faster and faster, closer and closer, ready to reclaim the abandoned seaweed. You finally open your eyes just in time to notice the barely visible sun cheekily twinkling on the swelling waters of the bay. It feels like being let in on a secret, being given that ability to see the shy brightness of a dull day, the quiet beauty of a grey sea. Isn't it the same – that gift of recognising the inner light in a seemingly less attractive person, of falling in love with every hidden treasure in them; the treasure visible only to you and, therefore, ever so dear; the treasure so genuine and pure that it does not need any sparkling frames to reinforce its value.

<p style="text-align:center">☙</p>

Some lives are commemorated with elaborate marble frames while others have to content themselves with rather mediocre grave kerbs. Despite being deemed a historical treasure by guidebooks, his tomb is easy to miss. A simple cross is drawn the whole length of the grave – no inscriptions and no mournful grandeur. Buried under the heavy vaults of St Nicholas's is Adam Bures, the Crusader. His humble tomb is a powerful symbol of the true spirit of knighthood: a plain, almost austere life, guided by dignity and humility.

Once the Middle Ages had drawn to a close, it so happened that St Nicholas's became Protestant, and remains such to this day. It does not feel that way though. Nor does it feel Catholic. Or Orthodox for that matter. The atmosphere is that of the house of God – simple, almost primal – maybe this is indeed what it felt like being in that church where St Nicholas himself was praying, at the time when no divisions existed. However, the divisions that did arise left a sorrowful and permanent mark on St Nicholas's: a gaping cavity in the place of charity that was meant to always dwell there. Deep inside the church, just to the left of the Crusader's grave, there is a window. Look at the panels left and right of the window frame: you will see two ancient bas relief sculptures of angels – both of them decapitated. They stand there, sombre and quiet, their invisible heads hung – a lasting reminder of what hatred leads to, and how it robs one of reason: brother against brother, Christian against Christian, defending religion and yet raising a hand to the house of God.

INIS MÓR

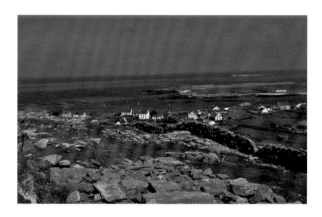

There are three things I treasure most about this island: its peace, serenity and timelessness. There is this prefix *an* in the Irish language. When used with an adjective, it means 'very' but the beauty of it is that it can be attached to nouns too, to intensify them. There are a lot of places in Ireland where you can find peace but what Inis Mór has to offer is *an-peace*, or *an-suaimhneas*, I should rather say.

The calming and charming effect of Inis Mór makes me think back to the time when I received bad news and had to take tranquillisers. I remember how quickly grief and despair miraculously disappeared, leaving me free of any feelings at all. Grateful though I was for the effect, I found it a bit disturbing that lack of emotion can be so relieving, deep and easy to achieve.

Instead of the deadly indifference medication gave me back then, Inis Mór, in nullifying all stress and sorrow, always inspires joy and lightness, a will to live and be happy. If you are ever on the island, stop

and listen to your body – and you will sense what *healing* means, and feel the creases on your soul being gently ironed out – by the breaking of the waves, the bittersweet sea breeze, the long grass creeping over the gravestones and the chessboard pattern of fieldeens scattered across the island.

A Day on the Island

When the weather is fine, it gets incredibly still in the afternoon. The tide is out; the blue sky is hazy with super-thin clouds which look like strokes of a massive brush; and the horizon line is softened by barely visible dreamy mist. The lunchtime ferry has arrived and is not going back for another couple of hours, so it is dead quiet at the pier as well. At those moments, you understand the true meaning of the Irish saying, 'When God made time, he made enough of it.' As you watch the tide gradually reclaim the beach, you can physically sense time – thick, viscous, satisfying – not slipping away through your fingers like water but drooping like good-quality oil paint from a brush; like creamy flour going through a sieve. Once you comprehend how plentiful time is on Inis Mór, you will find it easy to let go of it. I am not talking about poor time management here – 'Oh God, I have lost track of time' sort of thing – but a conscious choice. Letting go of time, gazing at the ocean, dissolving in the now, I find, is the height of freedom because at that moment you do nothing else but live.

Evenings on Inis Mór have their own serene charm. Sit outside, with a view of the harbour, and have a lazy dinner. There is quite a crowd on the old pier – a bunch of kids are jumping off into the (freezing!) water, and there are at least as many onlookers as there are swimmers. The air is so thick with freshness that it mutes all the screams and splashes: the little bodies silently disappear from the pier to cheerfully re-emerge in the lagoon a minute later. The majority of tourists have departed, so the locals can take it easy and go about

their everyday business in peace. Everyone in the village is busy, doing or fixing something, but no one is in a hurry or under pressure.

As the evening rolls on, a breeze comes from the sea. Finally, without making a sound, the last, 6.30 ferry slides into the harbour from around the corner and parks for the night. It is usually half empty; and the few passengers are promptly picked up and driven away into the depth of the village. I find the arrival of the last ferry quite symbolic – you can breathe out once it is parked – the island is 'closed' for the night, no one else will be arriving or leaving until next morning. Time to put your feet up.

The walk back to the B & B for the night has to be taken slowly: you need plenty of time to enjoy that special evening air. Freshness and purity, grass and leaves, the ocean and the seaweed, with a pinch of manure, come together to produce that special sweet-smelling air that you get on the Aran Islands at night. You feel you cannot get enough of it and need to breathe in again and again. The air is tasty the way spring water is: it is so basic and so fresh you simply cannot stop. If it is a windy night, you can take in even more air, blown your way by the crowns of suprisingly tall trees in the village. As you look up to see the branches sway in the mightly Atlantic breeze, you feel you become one with the wind, like Cathy and Heathcliff in *Wuthering Heights*; and then you glance even further up to see the vast starry sky – how much more liberating can it get?

Dún Aonghasa
Freedom is spilt generously all over Inis Mór, and its other manifestation awaits at the majestic cliffs on the western side of the island, the fort of Dún Aonghasa being the most popular spot.

The trick is to go there early in the morning to have the place to yourself. The vastness of the ocean is that bit more powerful then, the peace is that bit more encompassing, and the healing of the soul goes

that bit easier. As you sit perched on one of the granite slates by the outer wall of Dún Aonghasa, a feeling of detachment from the whole world comes over you. There is nothing but the endless ocean and grey, forbidding cliffs. You sit and watch, and let your thoughts float. As you gaze into the dark hollow beneath the cliff edge, you can just about make out the gulls. With ease and grace, they dart across the hollow, dive down to touch the water with their wings, and then up and further out into the open ocean, and back and down the hollow again. Isn't it what the freedom of spirit is – that effortless, aimless flight around the cliffs? One may well catch oneself longing to be that seagull when one's time comes, secretly hoping to be left here – neither heaven nor hell – to circle the cliffs with the birds, wander the boreens with the mist, swish through the stone walls with the wind.

A fresh gust of ocean breeze brings up the most chilling seagull screams from the depths of the cliff hollows. They make me think of the souls which, just as I was imagining, begged to stay and, their wish granted, they now mourn their paradise lost – not the paradise they were barred from, but the paradise they refused of their own accord. If only they knew how close it was – just a bit of bravery and faith to fly further out – it is west of these very cliffs, they say – over the ocean's mighty waves, towards the misty purple horizon – and beyond.[7]

Cill Éinne[8]
On the other side of the island, away from the striking Dún Aonghasa, there is a village, often neglected by most visitors. Cill Éinne is a curious sort of a place, poignant and ghostly to my taste, and yet mesmerising in its otherworldly stillness. It carries too many memories, there is too much 'used to' about this place. Even the stone walls, cheery and turtle-like in their pattern on the western side of the island, remind me of scars here – dry and old by now but carved deeply onto the very heart of the island.

Saint Enda used to live and pray here. There used to be a monastery, all over the fields, so extensive and close-knit a community that one of its churches came to be known as Teaghlach Éinne.[9] It all *used* to be here – until the monastery was dissolved and later destroyed with the arrival of the Cromwellian soldiers. The gloomy ruins by the water's edge are the remains of a Cromwellian castle and a prison. Further down the road, elevated above the sandy dunes, is a peninsula launching itself into the tidal lagoon like a ship ready to set sail. For masts it has crosses and for passengers the dead of the island. If there is anything at all that could warm a dead heart and lighten a grieving one, it is the lap of the waves at the foot of a grave and the rustle of the wind through the reed grass, grown as high as the crosses themselves.

Cemeteries are a good way to get to know a place – through those who used to live there, now the dearest memories of the local community. As I wander quietly from one grave to another, stories unfold. Here is someone who lived to be a hundred; someone else was taken on St Patrick's Day; here is a nineteen-year-old girl, the gravestone erected by her husband; a couple of people who happened to serve in the American army during the Second World War; a forty-two-year-old lady who died only a few months after her baby, and was joined by her husband many years later; a young man who died at twenty-three and got a 'forty this year' wreath, the grief of his parents seems still raw: they must be counting every year wondering how their son would be getting on in life now.

Suddenly, a new shiny gravestone captures my attention. I come closer and see a radiant face of a sixteen-year-old girl, cut into a stained-glass circle in the middle of her gravestone. I recognise her immediately – I saw her in a documentary on TG4 that I randomly chose one evening in yet another attempt to improve my Irish. It was the heartbreaking story of Shauna from Inis Mór who died of cancer. The programme showed her friends telling the reporter how they

were struggling to cope with her death and how they would come to her grave after school and tell her what had happened in class. I almost forgot about that story until that day in Cill Éinne when I recognised her face. Shauna's grave definitely stood out – not just because it was relatively new and the gravestone was modern-looking. It was because its every detail screamed of the heartbreak of those who erected the gravestone, and of the impossibility to come to terms with such an untimely death. Stained-glass yellow smileys around Shauna's face, more smileys carved on the gravestone itself, decorations with verses which call for positivity and hope – all these things placed there to try and defeat horror and despair with beams of life – *the light shines in the darkness, and the darkness has not overcome it.* There are plenty of souvenirs scattered around the grave, from England, France, and even the States. The world Shauna is never to explore is being brought to her – as if to compensate for all that life that lay ahead and was so quickly taken, in an attempt to keep her alive despite her death. There is also a bottle of Prosecco – must be a present from Shauna's friends – she is over eighteen now and sure, why wouldn't she like to share their excitement of having a first glass of bubbly?

I could not hold back my tears, so moving and thought-provoking the visit to Shauna's grave was. It has become my own little tradition ever since to come and say hello to her whenever I visit the island. I might bring her a souvenir from some exciting place next time I am on Inis Mór.

INIS MEÁIN

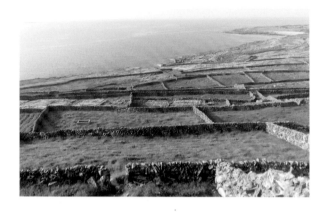

All my numerous trips to Inis Mór always start in the port of Ros a Mhíl onboard a rather classy and spacious ferry. As we are out in the Atlantic, the bow pointed in the direction of Inis Mór, I glance across the deck to catch a glimpse of a smaller boat lit up by the slanting beams that break through the purple clouds. 'Ah, the Inis Meáin ferry,' I think dismissively. The swell of the Atlantic is a bit too much for that little fella, and it looks clumsy and slow in its progress as it diligently digs into each wave – up and down, up and down it goes – stubbornly moving forward, towards the round cap of Inis Meáin. I smile with satisfaction as I know we do not have to go through the same ordeal onboard our big Inis Mór ferry. We are all guilty of a bit of the aul *schadenfreude*, aren't we?

What goes around comes around though, and finally the time comes when I step onboard the Inis Meáin ferry to meet my Waterloo as the wild Atlantic waters give our little boat a generous flushing. It is

digging into the waves so diligently that even if I wanted to glance to my right to catch a comforting glimpse of the Inis Mór ferry, there is nothing to be seen but the mighty Atlantic spray crashing against the porthole. *Never ever scoff at the Inis Meáin ferry* – lesson learnt, I get ready to disembark at a suspiciously quiet pier. 'Inis Meáin,' the crew member holding the ramp says to me in a low, confidential voice as I pass him on my way out. He glances to see my reaction. *Careful now*, his look suggests, *the trendy little Inis Oírr is the next stop.* But I am determined to taste the primal beauty of Inis Meáin.

The island, overlooked by the majority of visitors, feels eerie and abandoned at first. The village, unusually positioned away from the harbour, on a kind of a crest in the middle of the island, keeps a silent distance from the commotion on the pier. The white-washed houses, unimpressed by the increased traffic brought on by the arrival of the ferry, stare absent-mindedly way beyond the harbour. Some send expectant looks towards the big cousin of Inis Mór; the more adventurous ones long for the hills of Connemara across the bay, while those who like to stay closer to home simply look out over the neighbouring Inis Oírr.

The past is the present on the island of Inis Meáin. Or better still, there is no past and no present; there is life, as it was and as it still is, so quiet and simple that some might mistake it for stagnation. In actual fact, Inis Meáin is ever watchful. Carrying so much living memory, tradition and heritage, both visible and invisible, the island lies low, aware of the treasure it holds, careful not to splash it out with a sudden move, not to scare it off forever, not to get carried away with too much buzz and forget what should not be forgotten.

It cradles the faint memories of tropical seas that carved the island's iconic limestone. It frowns remembering the turbulent times that encouraged the building of Dún Chonchuir. It treasures the blessings of unnamed saints, humble in their monastic life and content to

fade into oblivion upon their death. It still hears the echo of Synge's footsteps on the path to the viewing point over Gregory's Sound. It safeguards the playwright's thoughts hovering in the corners of a humble cottage, now concealed by the low branches of an old tree. It remembers Pearse's gaze over the landscape, whose power and beauty might have later added to his determination to fight until the very end. It nurtures the Irish language – an unceasing subterranean spring that comes to surface here and there across the island – unpretentiously, naturally, in its most beautiful and harmonious form. It acknowledges the centuries of hard work of the islanders through the rhythmical rise and fall of grey stone walls – the most permanent and stable structure on the island. Solidly built and generally well maintained, the walls methodically cover the whole of Inis Meáin and act like a steel frame of sorts designed to hold the island together. Stern and timeless on a cloudy, windy day, the stone walls turn into delicate frames for sparkling emeralds when the sun comes out and sends its rays dancing over the grass patches across the island.

The roads, winding their way through the stone maze, feel only secondary: the walls determine their course, command every turn and keep them exceptionally orderly – no room for expansion, messy kerbs or, God forbid, U-turns. No lanes or cul de sacs, no confusing crossroads; you take a road, and it brings you exactly where it should – and why shouldn't it bring you to Teach Ósta, the island's one and only pub?

There is a certain initial shyness about the place which dissipates as you breathe out your tension, sit down and open your mind as well as your heart to the ways of this island pub. Everyone is welcome, no one is a total stranger, anyone can join in. If you do, this intangible yet painstakingly down-to-earth world of goodwill, laughter, *comhrá*, music and song will gladly expand, throw itself like a tidal wave over you and gently but insistently drag you in.

And then you will see it: the pub's darkness is not gloomy but cosy, its back room is not shabby but homey, with sweet, simple curtains that shield people from wild winds on dark days and frame a lovely picture of the bay on brighter ones. I like to imagine long winter evenings here – what a refuge this room must be, and how comforting it must feel being in, safe from the gusts outside – in this warm, humorous and simple atmosphere. A small pub on the edge of the open Atlantic, the only refuge outside one's home – the sheer idea of it might seem limiting. And yet it is one of the most liberating places I have ever been. When goodwill and laughter, talk and company are seen as blessings enough, who can take it away? That quivering light on a little island in the middle of the Atlantic looks tiny and powerless; yet, believe me, it is a hard one to beat.

My last evening on the island was not the one for the pub though. I followed the village road as it turned a corner, leaving the cottages behind, and continued on along the stone walls, into the wild, into the west. So much has become so dear. To catch another glimpse of the wild flowers that spill onto the roadside; to smile again at those wide-eyed camomiles that snuggle up to the rough craggy walls, shy of their happiness with such an unlikely partner. To fly away into fairy tales once more, where people live happily ever after in cottages by the big blue sea – that hut at the end of the road, most likely a hay shed, is happy to play along. One final bend, and the path comes to a sudden halt. It crumbles into blocks of shore rock, and the stone walls stand aside. The ocean throws open its arms: it is vast and full of vigour, its tangy, salty breath feels so close; its infinity is utterly mesmerising. The thatched hut respectfully takes a step back. The ocean hug – this is what I will miss the most.

To complete the loop of the island, I head for Dún Chonchuir, where a shy, overgrown path leads through the three walls that are being slowly claimed by ivy. In the mood for quiet reflection and a

bittersweet farewell, I step into the dún's inner circle, watching my every step, making as little noise as possible. Surrounded by the imposing walls, I feel a bit unsettled and alert, aware of every sound around me. I listen. Am I imagining it – a deep silent thumping, a soundless pulse under my feet, so perfectly echoed by the breaking waves on the beach down below? The rugged heart of Ireland, safely concealed behind the ribcage of stone walls, is beating.

Tread lightly, she is near,
Under the snow,
Speak gently, she can hear
The daisies grow.[10]

As the ferry gained speed, the unassuming cap of Inis Meáin got smaller and rounder before it blended into the blue morning mist on the horizon. Until we meet again.

ACROSS THE WATER
STRANDHILL

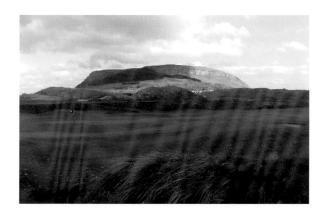

As a good old Bus Éireann bus manoeuvres out of Sligo and makes its way through the neighbourhoods, signs for Strandhill start popping up along the road. I love the confidence they give you – only a passenger, you feel reassured and in control – you know you are on the right track. This time, though, the Strandhill signs unnerve me. More precisely, it is the Irish that makes me so uncomfortable. I am looking forward to a classic seaside resort with tea rooms, outdoor seating, a promenade and a spa. And yet, how can you contemplate enjoying a lovely cone on the prom when constantly reminded that you are travelling to *An Leathros*?! The memory of that painfully familiar smell of a not very clean seaside public toilet pops into my head, followed by that of washing my hands over a tiny metal sink, doing my best to get them relatively clean for holding the cone. Jokes aside, *Leathros* has nothing to do with *leithreas*,[11] of course, and has a respectable etymology of its own.

Still haunted by the bathroom ghost, I venture out into the dusk in search of shower gel and shampoo that are inconveniently missing from my B & B room. Nothing makes you want to move down the country more than an evening stroll through a small town some time in spring. Houses, lanes and flowerbeds are lulled to sleep as the first street lamps come on. Life quietens down, and the air is warm and sweet, filled with scents of flowers, fresh leaves, turf smoke and manure. You breathe it in and yearn for that dull tranquillity of country life, those small towns – two shops, three pubs, St Patrick's Church and a Bus Éireann bus stop served three times a day. And the green fields. And the Atlantic. And the beauty of it all. Why would you ever strive for anything more sophisticated than that?

I am reading *Brooklyn* and wonder at how Eilis and Tony are so fascinated by city life. Here they are, on a crowded New York train, making their way to Coney Island. The beach is packed with sunbathers, and I am not jealous of their warm sea at all – to me, it is much more peaceful and enjoyable here, on the chilly Strandhill promenade. Why on earth would I need Coney Island, I shrug scornfully, only to discover later that same day that I am literally four kilometres away from … Coney Island! Never say no, never scoff at anyone – it will come back to bite you, swiftly and with a vengeance. Never mind Strandhill, after a bit of googling I find out that there are at least eight Coney Islands scattered around Ireland.

The American Coney – dazzling, bright, promising opportunities and fun – has long attracted both tourists and emigrants, flashing like a beacon from beyond the Atlantic. It never ceases to entertain, and the Statue of Liberty only shakes its head in amazement from across the Upper Bay – the music, the lights, the colours!

The Strandhill Coney is small and unassuming but come low tide, it sets the scene for miracles. Guided by fourteen stone pillars, cars set out on their brief journey across the water, ploughing through the

heavy tidal sand of Sligo Bay. What surreal bliss it must be, moving across the ocean floor in mellow afternoon sunshine.

She would shake her head in amazement too if she could, but her stony chamber is too small to allow even that. Forever standing to attention in her lonely tomb on top of Knocknarea, Queen Meadhbh dreamily watches those curious beetles creep across the bay. No, she is not yearning for the American Coney – she is longing to run down to the strand, to feel alive again, to dip her feet in the icy Atlantic, to feel its force, vastness and timelessness that are so evident here at Strandhill.

It is not your average sea with waves breaking rhythmically against the shore, one after the other. The Atlantic is one huge whole, one breathing organism. Waves are running towards the beach like the well-oiled wheels of a train, making a continual rumble that hovers over the beach and dominates the air. It reminds me of the humming noise of a cruising plane that does not go away until it is time to land.

Foam, produced by breaking crests, forms a misty blanket over the water. The sun comes out and lights up the green fields across the beach. The lush green looks dreamy when seen through a foamy haze lingering in the air. It makes me think of Gandalf speaking of the other world on the eve of the deadly siege of Minas Tirith: 'the grey rain-curtain of this world rolls back, and all turns to silver glass, and then you see it … white shores, and beyond, a far green country under a swift sunrise.'[12] It makes me hopeful that the afterlife will be something like that, beautiful and peaceful – patches of green peeking through a shiny veil of wave foam – there to remind me of the land I will have left behind.

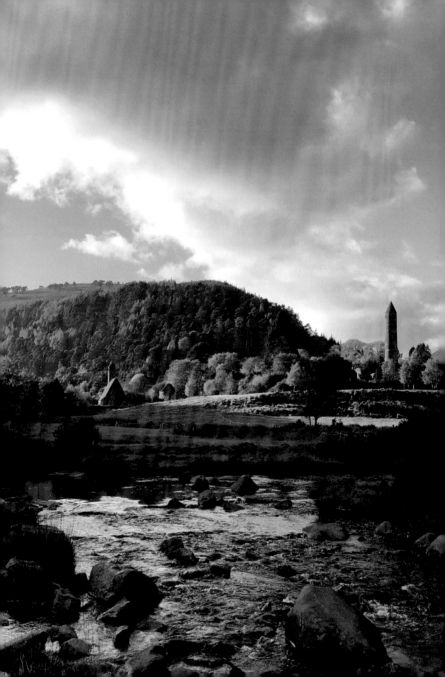

PART 3
OF MYTHS
AND MAGIC

MIDDLE-EARTH INCARNATE
THE BURREN

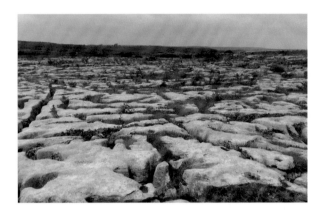

The Burren: its very name has a heavy ring about it. It sounds like a monolith, a single block, a finely sliced piece of landscape – well defined, predictable, and packaged to be explored. In actual fact, it is more like a quilt, a Middle Eastern bazaar, a performer who always has a new card under his belt, ready to amuse his audience. The Burren masterfully juggles all its diverse features, throwing them at you one at a time as you move through the landscape: the solemn, almost mournful grey of the limestone, the green valleys in between the stony slopes, cool shady patches of dense fir wood, forbidding crags and, down below yet beautiful above all, the restless Atlantic, triumphantly throwing its green waves against the already battered rocks.

I look at the cottages nestled under the broad shade of the Burren hills, perched right above the ocean. How special it must be – living with such might and beauty on your doorstep. I wonder if it ever

becomes dull for people but somehow I doubt it does. The ocean feels like a living being, a presence rather than a feature of landscape, and that presence must be difficult to ignore, as it is overwhelmingly more vast, ancient and powerful than any of the people who have ever dwelt by its edge. I wonder if that comes close to what the hermits of old felt as they spent their days in constant awareness of the divine omnipresence.

However compelling, the Atlantic is not the only power at work in the Burren. The place has a rhythm of its own – a long-forgotten one; a pre-historic cyclic flow of time, formed by ancient agricultural practices. The pastures, squeezed between the sea and the hills, are the source of vitality within the Burren, and this is where the cattle are kept throughout the summer months. The harsher gloomy uplands gaze calmly – not a trace of jealousy – upon the feast of life down below. Come autumn, the cattle will be driven up for winterage, away from the flooded meadows of the lowlands. This clever two-level system of hills and valleys is ultimately framed by the ocean, which, from its rocky hollows, sends up the wind and the rain – to batter and erode the rock, freshen up the fields and lull those carefree cows to sleep.

Many a visitor has travelled the Burren seeking tranquillity and contentment. Many a traveller has marvelled at its magic. So enchanting it is, indeed, that it even managed to conquer the heart of a famous and very refined English professor.[1]

❧

No doubt sensitive to nature and beauty, JRR Tolkien readily responded to the ways of the Burren, comprehended them, and paused in awe. Before him lay his own creation: Middle-earth in the flesh. I like to think this encounter felt like a reward, one's gut feeling

confirmed, a long-awaited result that has eventually emerged from hundreds of experiments.

In the lonely limestone-paved plateaus dotted with singular solemn boulders, Tolkien saw the wastelands of Mordor that Frodo and Sam had to cross on the last stretch of their journey. In the open spaces around the Poulnabrone Dolmen he saw the plains of Rohan, the exiled army of Éomer circling the standing rocks on their fine horses, scattered and disoriented by the madness that came upon their king. In the farmhouses of the central Burren, hidden behind the sudden vigorous greenery of the mossy trees, he saw Tom Bombadil's dwelling – an oasis of peace and cheer in the heart of a stern and treacherous world. By the Slieve Elva mountain, in a dark, deep cave, 'doves' hole', *Poll na gColm,*[2] he heard an echo of that unsettling sound that Gollum made, when, living in the depth of the mountains, he forgot how to form words. In the ancient Burren hills, shaped in a maze-like pattern, he saw the two opposing powers. In the sunshine, the slopes resembled the majestic and forbidding walls of Minas Tirith with its seven levels carved out of a cliff. Only a banner with a tree on it was missing – as was the Steward Prince standing guard on the hill top. On gloomy days, the imposing slopes turned dark and reminded him of the most hostile places in Middle-earth. From the Burren heights, looking down at Fanore, he saw a ring of fine gold forming a beach at the foot of the dunes. It glittered in the sun, reflecting wet patches made by tidal waves. He could hardly take his eyes off it, so perfect and striking it was.

But alas, in the roaring ocean, he did not see the long-sought comfort that the Grey Havens offered to elves. He instantly knew that the Atlantic, wild and moody, with a will of its own, bows its head to no one – neither the elven kings, nor the golden ring of Fanore itself.

NARNIA ON EARTH
THE MOURNE COUNTRY

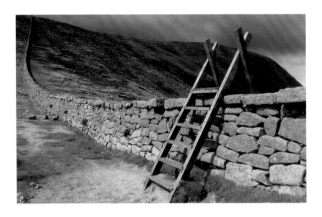

The Republic and the Six Counties. The South and the North. I have always sensed a difference but could not put my finger on it – no, not the accent, that is too straightforward. And we won't even go near politics and religion here.

It finally hit me after an overnight stay in Rostrevor: hobbits from the Shire and hobbits from Buckland. The Shire crowd, too comfortable in their beloved holes among green fields and dreamy hills, were forever suspicious of the more adventurous Bucklanders who dared cross the Brandywine river and settle down on the other bank. They loved boats and could swim – how scandalous! Were they hobbits at all? No doubt the suspicion was readily reciprocated on the other end. In actual fact, Bucklanders were just a tad unusual, and the feeling around the place a bit unfamiliar – not your classic Shire, so to speak; neither good nor bad, just different. This is probably the best (even if simplistic) way to describe how I personally perceive the

difference between the South and the North – they share the essential traits but differ in how these are manifest.

Just like the Brandywine that flows between the Shire and Buckland, Carlingford Lough separates (or rather joins) the two parts of Ireland; the only difference being that, unlike Frodo, I crossed the border of my own accord without any Black Riders breathing down my neck. But I did come here looking for some magic: I was hoping to see what inspired Tolkien's good friend CS Lewis – a native of County Down – to create the world of Narnia.

Kilbroney Park in Rostrevor and the glorious Mourne Mountains were the answer to my quest. As I stopped on a path crossing the valley at the foot of Slieve Donard, I looked around – the silent imposing Mournes, the crystal clear mountain river, the sun-filled pine crowns, and down below, a patchwork of green fields and the azure Newcastle Bay. This place has it all – every element of nature is packed into this part of Down, turning it into a tiny world of its own – it is only a matter of populating it with whatever creatures spring to one's mind.

Reflecting on his holidays in the Mournes, Lewis wrote that the landscape, 'under a particular light made [him] feel that at any moment a giant might raise his head over the next ridge'.[3]

How can a landscape make you feel that you are about to meet a giant? I thought I had hit a wall there with my ability to understand Lewis' sentiments, and so I did indeed – the famous Mourne wall. It is a sturdy stone structure, crossing the mountains in a graceful line, running up and down the slopes for miles on end, plenty of hillwalkers travelling along it, everyone with their own destination in mind, with their own peak to climb. It made me think of Hadrian's Wall (which I never saw except in pictures), of ancient times, the old ways, and adventures. The hillwalkers reminded me of pilgrims, moving slowly and patiently across the rough terrain; no, not pilgrims but wayfarers, folk, crossing the country, travelling on a mission – men, giants, dwarfs, maybe even fauns, who knows.

There are enormous wooden ladders scattered along the wall so that everyone can cross freely from one side to the other. The steps are truly gigantic as if designed with more than people in mind – I suppose in the Mournes you never know who might need to climb over on their track across the shadowy slopes.

Even if no curious creatures ever emerge from behind the wall, the magic is in the air – it is in the lull of the lush rolling hills, in the soft wide paws of fir trees, in the purple of the heather against the distant mountain tops. Look around, take it all in, and you will see that you cannot say for sure whether it is a fairy tale you are in, or just a place of stunning natural beauty. When the two interweave, all that separates them from one another is something thin, like a couple of coats and the back wall of an old wardrobe.

The first kind of magic the children from the wardrobe experienced was the wonder of a regally still, white winter and the mysterious light of a solitary lamp post in the middle of a forest. What first enchanted me at the top of Cloughmore Hill in Rostrevor was a magnificent clash of weather fronts, which I was a witness to. An onlooker. A partaker. Yes, standing at the top of the hill, a panoramic view for miles ahead, hardly a soul around, the wind mercilessly battering my little figure – I felt this did elevate one from a witness to a partaker and brought one closer to the powers in charge, whether you regard them as God or the energy of nature itself.

It felt like one of those factory tours – we, ordinary mortals, get to see how chocolate, butter, Guinness or crystal are made. My tour was about weather-making.

Spurred by the mighty wind, clouds gather thickness in a split second. They roll in a mad whirlpool over the lough, quickly hijacking one patch of blue sky after another, finally spilling over onto the hills across the lake. Mission accomplished. As if a spell has been cast upon the land, which has made me instantly forget all the beauty now cruelly concealed by the mist and drizzle moving like a grey curtain – in straps,

sideways, across the green hills, devouring the purple patches of heather and shrouding the fleecy fir trees. The kingdom of greyness and gloom, no hope in sight. Suddenly, the sun breaks through over the distant hills to the right, but the clouds over the lake firmly hold their ground and go dark purple. A counter-attack from the hills comes quickly – the brightest rainbow ever, only a wee bit of it visible though, shoots down onto the emerald fields. The wind picks up, instantly brightening the horizon, as the clouds ease their grip and retreat into the distant brown mountains on the other side of the lake. Until next time.

This weather victory, although not mine to claim, brought me confidence. However dark the curtain of pain and sorrow is, light and beauty are always behind it, never fully gone but waiting to be revealed when we least expect them.

Cleansed and reassured, I returned to Kilbroney Park Visitor Centre. As I settled down for lunch, I noticed a blind man enter the café with his friend who was guiding him through the door. It suddenly struck me that although that gentleman had come to this park, famous for its views, he was not going to see anything. And yet he came here, which was brave, I thought. He could have rebelled, he could have snapped grimly at his friend's suggestion – *there is no point in going there*. But he went – to relish the smells, the air, the sun and the wind – thankful for what he was able to enjoy.

There is a lot of humility and dignity, and, above all, strength, in making the most of what we have, in accepting the circumstances and in choosing to *live* instead of suffering.

Irish weather is a good mentor in this respect. Stop fretting about it – the views are stunning even in the rain. Maybe we should forget about bad weather, let it go as we cannot change it, accept it with love as part of this country – the way we accept the imperfections of our family and friends. After all, it was thanks to a rainy day that Peter, Edmund, Susan and Lucy discovered Narnia.

WHEN IN ROME
GLENDALOUGH

reland, thanks to its Celtic heritage, is often linked to all things mysterious and spiritual in that special, ancient way. This connection is no doubt both exaggerated and simplified by the tourism industry but, as they say, there is no smoke without fire. If that primal Celtic mystery is indeed still lurking around the country, the one place to find it is a crease between the two slopes at the source of the Upper Lake in Glendalough.

Two weary, ancient mountains lean over the reeded shore like parents over their baby's cot. White sand flashes somewhat menacingly against the dark water of the lake. That wild, overgrown shore looks so close, charming and attractive and at the same time treacherous and utterly unattainable. Even on a sunny day, faint mist lingers around that far end of the Upper Lake and snakes around the rocky slope, where St Kevin used to live in a cave. Tall pines along the opposite shore are

graceful and solemn, like a row of candles planted to guard the amber waters of the lake glistening in the afternoon sun. An oak grove down in the valley hides the ruins of Reefert Church. Baby ferns dot its walls, the roof is missing but look up – an oak canopy caringly covers the gap. A better preserved St Kevin's Church in the monastic city is the quintessence of harmony and simplicity. It is barely architecture, so masterfully is it woven into the landscape. A warm evening breeze with notes of freshly cut grass whirls around the church, hugging it as if it were one of its own wild elements. Evening time is refreshingly cool in the flood meadow by the Lower Lake. Only a silent pair of eager eyes is anxiously watching you as you walk through the dusk – a young deer, cautious and timid. As the sun is nearing the horizon, the sky mellows and mutes all sounds. The often loud rooks fly silently across the monastic city and circle and circle the round tower, slicing the air with their wings as if it was soft and rich like creamy butter.

The lakes, the forest, the mountains and the ruins are all united by a palpable sense of reverence. They stand still as if in awe of something that is but a distant memory, and yet powerful enough to have left an indelible trace on the landscape. St Kevin's vigil, once a permanent feature of Glendalough, is gone and forgotten but its echo, it seems, lingers on. It is so faint and fragile it is beyond human hearing but nature remembers – and listens.

You would think a place of such sublime beauty and serenity should only bring out the best in us. Surprisingly, all too often, it triggers raised voices, restlessness and pop music roaring from a loudspeaker in someone's backpack for the enjoyment of all around. Isn't nature supposed to elevate and transform?

In Glendalough, we are confronted with something we might not necessarily expect from such a tame, pretty place – an energy stronger than excitement, a quietness louder than music, a purity more overwhelming than all the colours of an urban hub.

Many of us think we desire peace, but when we come face to face with its perfect manifestation, it turns out not everyone can bear it. It threatens with silence and promises a meeting with oneself; it puts an end to a race for achievements – the race that, however exhausting, is a convenient shield to keep pain, unrest and the voice of one's heart at bay. In Glendalough, face to face with natural serenity, we see our shield shatter against peace, we feel silence strip us of our armour, and we become too vulnerable, too bare, too open to the truth. And we shudder – like fish taken out of water, flopping on the bottom of a boat; like youngsters on the verge of adult life, its range of opportunities gone into their heads; like Hamlet – *out of joint[4]* with the world around him. In a panic, unconsciously, we seek to dampen down that intimidating, alien force through whatever means we are most familiar with.

And so pebbles go flying into the perfect stillness of the Upper Lake, and after-dinner drinks at the local hotel all too quickly turn into a loud affair, as if in an attempt to drown out the steady gaze of the round tower across the road.

Eventually, the night falls, and gentle evening dew washes away the trials of the day. Glendalough exhales. Like a deep-sea creature, it had been lying low – so deep below the surface that the tempest atop did not disturb it.

And now, at dawn, it re-emerges – Glendalough as it was meant to be, the valley that stopped St Kevin in his tracks, and inspired many to sacrifice all things earthly for the absolute peace that it nurtures.

The glassy surface of the lake is otherworldly still so that every tree and branch is reflected in it to perfection. A faint breeze from the farther shore brings a blissfully sweet smell of pine sap melted under the rays of the morning sun. The breeze travels on: it ruffles the leaves of the oak trees in the grove and swishes through the ruins of Reefert Church – a mere sigh, a tender stroke on the cheek. A playful

gust gently tosses the drooping branches of a fir tree by the round tower, like a lover, affectionately casting aside an unruly lock of hair fallen across the face of his beloved. In the shade of dense foliage, crystal drops gather on mossy rocks. They creep closer and closer to the edge, swell and finally let go. Plink. Plink. Down in the meadow, a young deer raises its head – and listens.

Vigils are not just for monks, and this one is definitely worth tuning into.

A HAPPY HEARTBREAK
CROAGH PATRICK

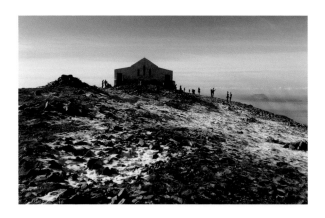

igh above the shops and the pubs, in the middle of the Octagon, on a tall(ish) column stands a statue of St Patrick. Not Patrick the bishop but Patrick the boy, Patrick the shepherd. I wonder why Westport opted for this particular image. *Strength made manifest in weakness*? *God opposes the proud but gives grace to the humble*? Or maybe it symbolises the start of one's journey to Croagh Patrick. Indeed, no matter how experienced we are, every climb up the Reek is always a new adventure. Like children let out into the strange, big world, we set out on this trek, not totally sure of what is awaiting us at its end. Later, we will all come back to the Octagon with some wisdom gained and possibly with a tiny part of ourselves transformed.

It starts in a quiet shady lane. The damp from the brook and the abundance of fuchsia make it almost tropical. *Deora Dé*[5] they are

called in Irish, those drooping maroon flowers. The sweat of blood, the crown of thorns – the sheer thought of it would make you shudder. Or is he weeping for us all, and those gentle petals are whispering of the hardship ahead?

It is so easy to lose heart at the very start – but a few metres ahead, starkly white against the dusky slope, stands St Patrick, generously encouraging everyone in their intentions – believer or non-believer, may they all safely accomplish what they have in mind today. Patrick the bishop, Patrick the transformer, who knows all too well that faith and determination move mountains. The stream hurrying down the slope is echoing Patrick's confidence – bubbly and unstoppable, it is dancing over the pebbles, not a bit embarrassed by its noticeably brown water. It is crystal clear, and this is what really matters. Never mind the form, look deeper, look harder.

The iconic view over Clew Bay is now taking shape – its renowned 365 islands start to transpire through the misty morning light, their rose edges roasted by the magical beams of late winter sunrise. One of the islands used to belong to John Lennon; I never knew which one, and I feel I hardly care – they all belong here, in Clew Bay, like pieces of a giant jigsaw. They accompany and reward every climber – a miraculous kaleidoscope that turns and regroups with every bend of the path to eventually settle into that space-view shape that reveals itself to those who reach the summit.

But first the saddle – a solitary, shady part of the journey with treacherous winds coming from a dark valley far below. A patch of fir trees, sprung from the peat, out of nowhere, bristle angrily under the walkers' gaze. A tiny lake at the foot of the slope is but a drop of ink – harmless but deeply unsettling. When the sun comes out, the lake mocks the light by turning it into threatening sparks on the surface of its dark waters. The trick is to keep moving – through *forest savage, rough, and stern*.[6] Fear and doubts are no phantoms but they cannot

be allowed to lead the way. Real courage is to acknowledge the fear and then turn away from it to face the true path you are walking. Here, on Croagh Patrick, that path is a clear steep curve winding its way to the summit, shaped like a defiantly raised eyebrow above calm and confident eyes.

Clay, sharp rocks, biting wind; there is hardly a minute to look up, the magical vista of the bay only momentarily reveals itself from behind the slope – clay, sharp rocks, biting wind. We are often reminded *to lay aside all earthly cares*[7] to make room for the spiritual. On the slope of Croagh Patrick, all cares – heavenly and earthly – evaporate in the face of clay, dust and sweat.

More rocks, more cold stone surface under the clutching hands, but suddenly, above it all, there is a flash of whitewash. The ground goes flat, and the pointy roof of a humble weather-beaten chapel beckons in the sky ahead. The Clew Bay islands, that looked a bit messy, as if heaped upon one another, from down below, are each in their own places now. This natural order comes simple and clear at this height; and the heart, that has been desperately pounding on the slope, freezes in awe – *this* is what all the sweating has been for. To become part of absolute beauty, to gain an insight that is unattainable without pain. To learn to believe that one day all our sorrows will arrange themselves into a jigsaw, like the islands of Clew Bay, and that this jigsaw will somehow reveal the significance of our troubles.

It is hard to leave a place so dearly gained so I walk the summit in circles, round and round the chapel, giving my mind time and space to fully absorb the joy of accomplishment and the immense relief of having literally left the world behind. Through the fogged-up glass of the chapel door, I can just about make out a spartan interior – and St Patrick, looking at me from across the altar window. The statue is surprisingly bright for this damp little chapel. Green and white garments, sleek chestnut hair and eager dark eyes shining with

energy and strength. He looks young, not as young as Patrick from Westport but a man in his prime when youth and experience strike that perfect but alas short-lived balance. Patrick the doer, Patrick who challenged druids and kings. Patrick who drove away snakes and braved the elements at the top of this very mountain.

'How peculiar,' I think, as, on my way down, I start noticing this same hardiness in the demeanor of those only beginning the ascent.

A boy, who looks only six or seven, is patiently working his way up the slope. Some boulders that cover the path are too big for him, and he has to make a real effort every time he steps over them, constantly adjusting his round glasses in clumsy plastic frames. He does not strike me as a very sporty sort of boy but he seems to understand that there is something more to this climb than physical exercise. He holds on to his father's hand, and there is a palpable sense of trust and mature friendship between the two. I somehow know they will make it to the top and come back safely to that reward of an ice-cream from the coffee shop down in the car park. A gentleman well into his seventies, his trusty tweed cap pushed back, cautiously picking his path; a visibly overweight young man, sweating through every step; a gentleman in his prime, patiently climbing barefoot, slowly, step by step as it hurts and there are no rough trainers to give him that extra grip he needs on the last stretch to the summit. All this effort and dedication, religious or not in its root, is truly humbling.

With every such encounter on the slope, I feel my heart crack ajar until self-absorption, arrogance and notions ooze out through that opening. By the time I am back in the village, my heart is broken – in the happiest of ways. As it lies open, light, empathy and content gush through. They fill my chest and expand there like an invisible festive balloon that eventually grows so big that it makes my lips break into an involuntary smile. What a joy and privilege it is to be carrying so much gratitude and bliss. It feels like being in love when

you have a world of happiness in your heart, of which passers-by are utterly unaware. So I grow protective, as I move slowly along the busy streets of Westport, doing my best not to spill all that precious light that twinkles inside me.

Dodging the hustle, I eventually find my way to Auntie Nelly's sweet shop. *Man does not live on bread alone* but the opposite is true as well. Back to the Octagon, where it all started. An outdoor table, dreamy afternoon sun, a creamy pint and a *shneaky* marshmallow from a paper bag on my lap.

The staff will turn a blind eye to this little treat. St Patrick, looking down from his column, will smile to himself as he ruffles the woolly curls of the sheep by his side. Patrick the boy, Patrick the shepherd.

THE WIND REPUBLIC:
REPORT TO HEAD SHEEP ON ARRIVAL
ACHILL

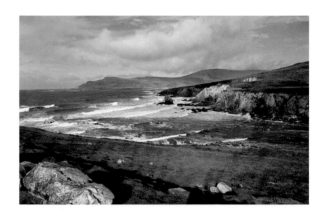

W hat can be more straightforward than an island linked to the mainland by a 200-metre bridge? Obvious, predictable, transparent – I was secretly worried I would be bored by Achill's ordinariness. Fat chance – wait until it spins you in a whirlpool of Doogort, Dooega and Dooagh and blows your brain out on Keel (or Keem? No, definitely Keel) Strand.

First things first though, Achill starts with mountains: distinct brown peaks guarding the island, bare and utterly detached – emanating neither the joy of the green hills of Kerry, nor the heartbreak of Connemara's Maamturks. As the day draws to a close, a misty, sun-rich, low light envelopes the rocky giants. It so perfectly illuminates the landscape, it even feels a bit artificial – as if a secret projector were switched on somewhere across the ocean to get Achill

ready for that perfect photoshoot. No wonder the island has long attracted artists of all kinds, including Paul Henry, the master of Achill's boundless sky.

Voluminous, fluffy clouds brush against the tops of the proud-standing mountains. They grow into giant candyfloss, taking more and more space, disproportionately expanding the sky, so that the landscape beneath becomes even more lonesome and acquires a haunting extraterrestrial touch. When we admire nature's wilderness, we often call it pristine, virgin, preserved in its original, pre-human state. Achill's beauty has more of a post-civilisation feel about it: reclaimed rather than untouched, rewilded rather than primal, deserted rather than uninhabited, liberated – bordering on anarchic.

Local sheep seem to be running the island these days. They haunt every path, ditch and garden; they calmly and confidently wander through cemeteries as they know no one will dare shoo them. They guard the turf and walk the roads; they claim right of way and fix you with such a severe gaze that you feel the next sheep around the corner will bar your way and demand a toll for using the road. Like ghosts, they appear from airy mist, emerge from behind turf hillocks, and then duck down again, visibly satisfied with the fright they have given you. 'Serves you right,' that vindictive look in their eyes says, as they watch you, uncomfortably hurrying up the road, half-scared and half-annoyed at yourself for suddenly feeling so sheepish because of the ... well, sheep. To be fair, though, isn't it only natural that sheep make one feel sheepish?

While sheep roam wide and free, Achill cottages huddle together like a scared flock; villages somewhat timidly nestle under the hills or dot the curves of the island's bays and coves. Houses look ruffled and confused by the unceasing breeze from the Atlantic and the advance of the bogs and hills from behind. They feel small and fragile: between the peaks and the big blue sea, always on guard, never at rest, conscious that it is not only the living that dwell here.

Every village is a strange mix of houses. A lot of typical white cottages – a car parked at the front, turf smoke coming out of the chimney – share a space with a much smaller ruin of a grey stone cottage, hiding somewhere at the back of the garden – the original dwelling that the white cottage replaced. It makes me shudder thinking how cramped, cold and hungry it must have felt in that shed of a house; how much grief is still trapped in it, locked away at the back of the new cottage.

Other houses, both old and new, right in the middle of a village, stand abandoned – their owners long dead or gone, having had to flee the famine or more recent unemployment. So there are their cottages now – blinking at you blindly with their dark, often glassless windows, the white of the walls washed away with rain, the gate still there but the path overgrown. The wind is raking defiantly through the wilted grass in the garden, whistling over the battered roof and through the broken windows. It knows there is nothing and no one to stop it from causing havoc. The only bit of light that dares stand up to this desolation is timid bunches of daffodils that have sprung up here and there in front of the house, fighting the debris of wilted grass. Poor little things have been going on autopilot for years, grieving the life gone and yet popping up every spring, in the hope that someone might return.

The daffodils are right, they do return.

I like to imagine that strong winds blowing from the Atlantic bring the dead back home: from America, from the depths of the ocean, from the graveyard around the corner. They rush back to their cottages, alas in ruins now, whistle through the windows and frantically fly around the place like someone who has discovered that their house has been broken into and turned upside down. And then, full of grief and despair, they leave, rush further down the village, attracted by the lights in other houses; they knock on the windows and rattle the doors, *let us in, let us in, we are come home.*[8]

I wonder if John J. Kilbane ever returns. He must have left Achill in the 1880s. Did he miss it? We will never know. Did he keep telling himself he had made the right decision, as America had given his son[9] a bright future and world fame?

That February night in Achill Sound, I did not dare open the rattling window. Whoever had come home, I hoped it wasn't John. If he ever returned, all he would find is his son's bust on the side of a village road, looking miserable and small against the mighty mountains and the dark waters of the Sound. No one but sheep stop by – for good grazing of course. Isn't it heartbreaking how short-lived our dreams turn out to be – how much they matter to us, how much we sacrifice for them and how quickly they are forgotten: a few decades on, no one cares about our joys and tears anymore, no one bothers to think we once were.

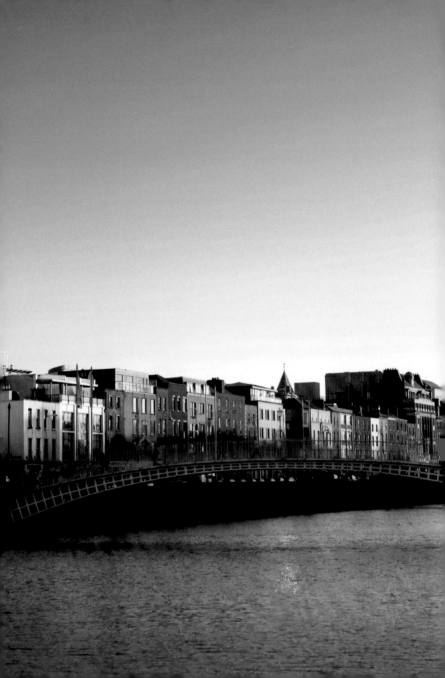

PART 4

A PORTRAIT OF DUBLIN AS A GRAND CITY

EARRACH

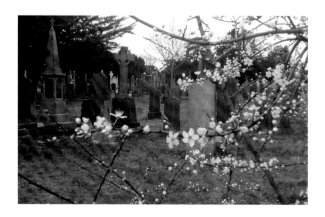

How many times we have summoned it in our dreams – a forceful, loud, jubilant march that will sweep away the bleakness of winter. A triumph of budding life over a deadly slumber. But spring treads lightly and deals her fatal blow with a weak and gentle hand. In fact, it is no victory at all but a miracle. And miracles happen in silence, at the darkest hour, when we are at our weakest and most vulnerable.

Tall, sombre oaks, watery skies, worn-out earth, hungry squirrels darting around like mad, slivers of overnight ice, sharp as a knife, floating in the pond. A timid ray of sunshine – surprisingly warm; blustery wind, still wild but smelling of freshly upturned soil; wide-eyed anemones popping up in circles, and baby daffodils, happily joining them in a cheeky fairy dance around the gnarled weathered roots. The old and the young, the constant and the momentary, the rough and the gentle – out of opposites, perfect jubilant harmony is born.

First cherry blossoms, pale with night frost; powder blue sky, delicate and mellow; hazy light pouring over the city; a greenish mist nestled in the trees, soft and feathery like a baby's hair. Stumpy crocuses – a handful of yellow and purple confetti sprinkled over a lawn; modest, aristocratically laconic snowdrops, and the bravest of them all – flocks of daffodils, grown high enough to fall victim to a cruelly raw wind. The white ones are faint with silent, well-concealed horror in the face of the wintry chill. The yellow ones, blushed with excitement, are measuring up to their formidable foe. Daffodils see winter but believe in spring, they feel the cold but think of thaw winds, they grow on graves but bring the message of life. Neither boisterous nor sombre but perfectly serene, they nod their yellow heads, all over Glasnevin cemetery, spreading the word of hope among the living and the dead. In spring, when life and death should clash the hardest, they unite instead in a shared sense of anticipation. Buds bulging with leaves; lilies waiting to spill their scent all over the garden; a stony tomb ready to burst, come dawn; reflection, pregnant with action; seeds angrily trampled into the ground – did they not know they were sowing new life?

Little Easter

St Enda's Park in Rathfarnham is dominated by the Hermitage, which once was home to the Pearse family: Patrick, Willie, their sister Margaret and their mother. It also functioned as Scoil Éanna,[1] an Irish-language school founded by Patrick Pearse. Back then, the park was a hive of activity: innovative ideas, outdoor classes for boys and momentous decisions of their mentors. How intense those reflections must have been: pondering life choices, contemplating Ireland's future and eventually arriving at the necessity of sacrifice.

These days, St Enda's has downshifted to a quiet local park. Like a dormant volcano, it lies low and dreams of its glorious past when it was all a-sparkle – so dazzling in fact that it burnt out all too quickly.

One bright, sunny day in May, just a week after Easter, I am in St Enda's, privileged to catch a glimpse of that dashing vigour – triumphant and doomed – that once dwelled in the park.

<div align="center">❧</div>

I step into the walled garden, Patrick Pearse's garden – and suddenly the careless sunny mayhem with toddlers on bikes and young hurlers on the lawns is gone, giving way to striking solemnity. There is always this special quietness about the garden, with the fountain gurgling in the middle. This is where life, death and eternity come together. The stillness of the garden mourns Pearse's death. The bright tulips and the sun, twinkling through the fresh greenery of the trees, promise the triumph of life and hope. The fountain with Pearse's last poem engraved around it completes the circle, and makes me think that both life and death pass but eternity remains: 'And then my heart hath told me: | These will pass, | Will pass and change, will die and be no more.'[2]

Moved by the poem, I make my way out, through the side entrance which unexpectedly opens into a cosy yard with a café and outdoor tables. The saddened heart warms up again and, purified by the quiet grief of the garden, I happily step into the welcoming yard – through the gates of purgatory into the tea lovers' paradise.

And then – it is pure sun, the green of the earth against the blue of the sky, a lawn speckled with sunbathers and daisies. A feast of life. A triumph of victorious joy. No disturbed ghosts haunting the place in despair over the life lost so suddenly, no hopeless grief for the man who left his house never to return. A week after Easter, it feels like a special little Easter has come to St Enda's. Do not weep, for *he is not here.*

What is here is his legacy, and I come back one moody afternoon to learn more about it and to visit Pearse's house, which is now a museum.

I am the only visitor, which allows me to engross myself in the history and atmosphere of the place. The ground floor is taken up by a new exhibition which tells the story of Pearse's life, whereas the first floor is the house itself, left very much as it once was. The exhibition ends with a noticeboard where visitors, mainly schoolkids, can pin a note with their thoughts. They make quite a read, I must say. *He was a man* turns out to be a popular theme. Another note is a child's touching attempt to write something in Irish. *Tá sé go hero*, it reads. The fact that he completely messed up the grammar makes the note even sweeter; it is the thought that counts.

As I enter the rooms on the first floor, I somehow feel as though I am in a private house whose owners are gone for the summer but are expected back soon. Only the soft buzzing of temperature-controlling machines reminds me that I am in a museum. Here is a cosy living room with a piano and a majestic harp. Here is Pearse's study, the very room he left, heading out for the Easter Rising. His table, his books, his letters. The shutters are down although it is midday – the only real sign of mourning in the house.

The warm garden café is especially welcoming this windy afternoon. The interior is simple but pleasant, very much in the spirit of Scoil Éanna. Wooden tables and chairs, old-fashioned posters, illustrating basic Irish words – *leaba, madra, bord* ... The menu is bilingual; your milk jug says *bainne* on it, and your sugar bowl is filled with *siúcra*. The bathrooms on the side of the café are labelled *Fir* and *Mná* with no English attached. A thought crosses my mind ... Believe it or not, a minute later it becomes reality as a German kid runs out, screaming to his mother that he went into the ladies!

As evening chill settles over the park, I head for the gates, pausing on the lawn, by the flag flown at half-mast, and Pearse's bust beside it. His bronze eyes are thoughtful and calm, a distant look of a man who has risen above both life and death.

SAMHRADH

Ninety-seven, ninety-eight, *ninety-nine* ... summer!

Cones, flakes, kids, adults, chocolate, raspberries, sprinkles, promenades, parks, streets, quays. The Liffey is glittering in late-morning sun, and a cheery sea breeze is playfully tossing the crowns of palm trees on the boardwalk. Dublin acting Mediterranean. Long warm evenings, muffled sounds of a makeshift disco in the distance, the chats, the craic and the Guinness, pubs spilling over onto the streets, the buzz of a beehive – chaotic and contagious. Jazz tunes floating down Grafton Street, seagulls circling over roof terraces, their hungry eyes disapprovingly scanning those G & T glasses with stawberries floating on ice. Summer is no summer without strawberries – smelling of sunshine and Wexford coast, ripe, bright and full of juice. Strawberries and cream – why do we like them so much?

'Do you remember the Shire, Mr Frodo? It'll be spring soon ... and they'll be sowing the summer barley in the lower fields ... and eating

the first of the strawberries with cream. Do you remember the taste of strawberries?"[3] – two exhausted and hopeless figures crawling up the ash-strewn slope of Mount Doom.

Perhaps we like strawberries because they remind us of a carefree life we all yearn for: the life where simple joys are enough to make us happy, and where there is no worry or pain that could overshadow that humble bliss. Perhaps we like strawberries because they take us back to our childhood.

The Buxus, the Twister and the Sea Air

Speakers of different languages tend to rightfully boast about the untranslatable riches that their mother tongues possess: the German *schadenfreude*, the Danish *hygge*, the Swedish *lagom*, or the Russian *toska*. Plenty of interesting words out there. And yet, every summer when the sun eventually arrives in Dublin, I am lost for words. Warm, viscous air, musky floral scents intensified with nightfall, crisp saltiness of the sea, ripening blackberries in the hedges along the road – all of it casts my mind back to the carefree summers I spent in Sochi, on the shores of the Black Sea. Bitter-sweet homesickness for one's childhood is the best way to describe it. Not *wistfulness* though – there is too much sadness in that word.

It is early morning, still a bit cool, hazy sunshine growing stronger with every minute. I am on my way to work. A light breeze brings the smell of the sea, fresh and gentle, full of salty bitterness, with notes of dried seaweed and sun-soaked pebbles – a nice reminder that I live in a harbour city.

The air smells of holidays, and I smile as I think of Sochi. We used to stay in a seaside village but would go into town for an early Mass on St Peter and Paul's day. Strolling down sycamore-lined streets after a hearty breakfast in a little café, as light-hearted as I had ever been, I would observe the locals – slightly overdressed to my eye, hurrying

to their offices on a glorious summer's day, blessed to be living in a seaside town but hardly noticing it as they went about their business. Little did I know that one day, on the shores of a different sea, I would be breathing in that same warm sea breeze, no idle onlooker anymore but one of those fascinating locals – marching to work, mid-July, tights on, true to what I preached – feeling blessed to be living by the sea, grateful for it every single day.

As I walk home, it starts to cool down. Buxus shrubs give off that distinctive pine-like scent, their robust shiny leaves melted by the afternoon sun. I know that smell all too well – it used to fill the evening air in Sochi, promising a carefree night and another warm day to come. These days, buxus smells of happiness, childhood and being safe in a place I loved, with those I still hold dear.

I look forward to the dusk and a thick blanket of a summer's night – I can't believe how dark those nights are. The air smells of warmth, freshly cut grass and wilted flowers. That sweet-scented breeze is gently stroking my cheek – not all is lost, there is still love and happiness in this world. On those summer nights, it seems so real, so deceptively close, that all the troubles shrink away, and all the worries are lulled to sleep – until the autumn chill takes hold.

∽

Saturdays are beach days in summery Dublin. The DART, having served the commuters during the week, feels like a holiday train, a summer alternative to the famous Coca-Cola truck. Shorts, sunglasses, picnic bags, rugs sticking out of totes, an odd bikini strap gone astray from under a T-shirt.

As the DART enters a tunnel, I think of Sochi again – how I held my breath in the dark, knowing that once the train came out the other side, it was time to get off for another summer holiday in our lovely

little village. As the end of the tunnel approaches, the DART speeds up, as if excited to surprise us all, when a second later it shoots out into the light again, to reveal the Mediterranean beauty of Killiney beach. The windows are open, and a fresh sea breeze storms in, making everyone look up and hold their breath, no matter how many times they have made this journey.

The damp subway leading down to the beach – dirty, stinky, dodgy, all things depressing – is the only thing of its kind that makes me hopeful. Another two steps, and I am on holiday; another two steps, and I am back to childhood. The same pebbles, so awkward to walk on barefoot, the same seaweed midges, the same steepness as you go into the water and struggle to find your footing as you swim back towards the shore.

'Mum, look, I am going to dive, look, I'm doing a forward roll, watch this now' – it took me years to figure out how awkward and unimpressive those tricks actually look.

'Dad, I am doing push-ups, Dad, I'm literally floating, look, Dad, I'm doing a split now' – a chubby little girl with a unicorn float is splashing in the Irish Sea. I can't tell the difference between what are supposed to be her push-ups and her splits but I know it is all terribly important to her – she is feeling like the queen of the sea.

Like in Sochi, I watch people go into the water – excited and energetic, with a spring in their step. Then that inevitable pause as the water hits their knees, and the reality dawns on them. Some bite the bullet and dive in. Others grow pensive. They stop and gaze towards the horizon, some take themselves through the torture of rubbing the cold water into their arms, shoulders and belly, prolonging the misery. They all get in in the end, and I follow suit.

It was a bit warmer in Sochi, which allowed for volleyball in the sea and a bright green Twister ice-cream after the swim. What a treat it was for me back then, hobbling on those awkward pebbles all the way

to the beach café, never mind the pain, quick, quick – I was always nervous the ice-cream would sell out by the time I got there.

These days I watch beach hurling, always have a cardie handy and enjoy a cuppa to warm me up after that baltic swim.

FÓMHAR

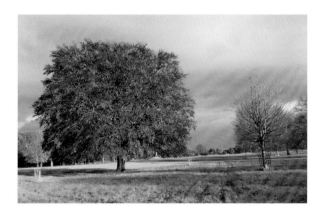

We swan into summer, rush into spring, dance our way into winter, lured by Christmas lights, but autumn – saying goodbye is hard. Shifting from foot to foot, we linger, brushing off that earthy smell of wilting leaves and the creeping chill in the evenings. Soon, it grows too real to be ignored so we dive into autumn – one crisp morning, straight down a dreamy tunnel of yellow brightness; linden branches, heavy with wet wilting leaves, drooping over the walkers' heads. Do we still have to call you green? Civil servants, bank clerks, office workers hurrying across the park, cheery hats with bobbles, colourful coats, trainers for that extra spring in the step, *bright-eyed and bushy-tailed*, as they say, disciplined by the cold air and infected by the enthusiasm on campus across the road. Oversized jumpers and elegant ankle boots, creativity and casualness, strolls across the cobbled square, a world of opportunities ahead, leisurely coffee, the campanile, nooks and crannies of the library,

the first fire in the dining hall. The homey smell of turf in the air, the smoke snaking around the street lamps, a whirlwind of leaves at the crossroads – or is it the spirits of old tossing about in those gusts. The glow of pumpkins by the doors, a hot whiskey on a stormy night and *uaigneas*[4] for the time gone by, the past never to return, from where, it seems, the turf smell comes. A yarn for tales of kingdoms and warriors, great deeds and enchanting adventures. The summer is over but the urge to travel only intensifies – to roam, to wander along paths misty and mystical, further and further into the woods.

The Phoenix Park

I used to jog past lindens, beeches and oaks, determined to make it to the Áras[5] and back: working out is good for you, they say. Or I would walk through pine groves, my deer-antennae on high alert – those graceful creatures are not to be missed. My heart still pounding, I queued for a cuppa in the tea room, all tense and impatient for a treat, jerky and worried there would not be a spare table for me.

These days I have downshifted to a takeaway tea, some gnarled beech roots for a seat and the dreamy Dublin hills to feast my eyes on. When Samhain[6] draws near, though, the sun is too low to let me see anything beyond the cup in my hands.

The footpath, which so familiarly winds its way under the trees, has suddenly grown longer under those pale horizontal beams of the autumn sun. The sky – the gentlest hue of blue, light and airy – is unattainably distant and thus pristine, a perfect background to the wild splatter of yellow and orange of the mighty beeches. Each leaf is lit up, bright yellow in the middle but dark orange, as if slightly burnt along the edge. Beech crowns sparkle in the sun like a candle flame, promising the joy of Christmas baubles, fairy lights and turf fires – all things festive and cosy, life full of laughter and merriness. Oh that deceptive beauty of autumn – when it gifts with one hand and

makes ready to pitilessly strip with the other. Lindens, less fortunate than beeches, are autumn's first victims. It takes one stormy night to shatter their golden crowns to pieces. Bare and dispossessed, they throw their branches – mournfully and defiantly – into the air, asking the cold desolate sky for justice.

Coming with a freak biting wind, thick uncompromising clouds quickly hijack the sky, casting heavy shadows across the land. Under that depressed light, the mound of the Papal Cross makes me think of Golgotha rather than a pedestal for the celebration of Mass. As hardly visible mist snakes around the base of the cross and the doomed light of the day struggles to penetrate the pale cloudy shroud, I mount the stone steps to come face to face with the eerie breath of autumn.

The top of the hill is a perfect vantage point, with the Dublin Mountains in the distance and a vast open space at its foot. All is mute and still, people crossing the field down below look small and shadowy; only restless rooks break the silent spell, cawing and circling over the sleepy ground. The soil looks raw and vulnerable, laid out to rest, ready to embrace the sting of winter.

Weak beams of the wintry sun slide down the slopes of Dublin hills, penetrate the branches of bare trees and finally pour onto the sleepy field at the foot of the cross. The sunshine of a cold and transparent kind. The *abandon your hope ye who enter winter* sort of sunshine. The distant grove above the brook is lit and not lit, the air is misty and yet clear, the hills shiny and pale at the same time. The much-praised green fields, now awfully composed and pale, are devoid of the summery, earthly energy of human life. Instead, they reveal bleak mystical shades which have always been buried underneath, hardly visible until now.

It suddenly dawns on me – this is what the original, true, Celtic Samhain was about. In the incredible quietness and bleakness of late autumn, people saw the border between the earthly and the spiritual

world get thin and blurred. For once, in those dark October days, they felt the supernatural take the lead from the earthly.

Just like trees shed their leaves, revealing every twig and branch, so the hassle of human life comes to a standstill, and the veil falls from the earthly world to bare the spiritual behind it.

The tree candles flash one last time – and burn out. My lovely park – the splendid fiery Phoenix – finally gives in to Samhain, folds its wings and falls to ashes.

GEIMHREADH

Achingly cold rain, merciless hail, furious wind by the sea – never mind the cobwebs, it will blow your soul out. Dashingly clear skies – the cold beauty of the Snow Queen – stretch over the Poolbeg pier, and the red lighthouse beckons like the Northern Star. Brisk walk, oversized scarves, jazz music from the coffee van, hot whiskeys available too. The chill, the ripples, the bridges; the gusts are so wild, the strings of the Samuel Beckett harp are about to break out in a tune; hats with bobbles, raised collars, windburned hands, ballerina shoes – they look surprisingly elegant with winter coats. The comforting crackle of the Bank of Ireland fireplace; the childish joy of Christmas jumpers flashing through the folds of that slick coat; thickets of holly all along Grafton Street. Fog horns in the dark of the morning, the light that never fully breaks, the Liffey, sedated with the gloom, flowing unconsciously through the city. The people crossing the river look miserable to the point of indifference, like those poor souls on the

banks of the Styx. Early dark nights, street lamps shivering in the wind, the bone-chilling damp of the Liffey crawling into the city – north and south – sneaking its slimy tentacles into already draughty houses. Hot water bottles, leg warmers, Aran sweaters, chunky socks, tiny alien-like heaters rotating by the sofa – that damp will pull the life out of you. A cup of tea gives up the ghost, and a thin thread of steam mournfully floats across the room. Through the never-ending darkness, a bell tinkles. An old carriage makes its way through the streets, all wrapped in fairy lights and tinsel, the horse patiently wearing its newly acquired antlers. Shapely candle bridges and stumpy single candles beckon the weary traveller: stop awhile, the table is laid. Mulled wine, pints, prawns, cranberry sauce, the roast, minced pies and a drop of Baileys. A much-needed stroll on Dollymount Strand, a deep breath to recover the senses. Light and dark, having played cat and mouse for weeks, eventually clash on the shortest day of the year, on the ancient battlefield of Clontarf. The sun does break through the black clouds but it is so low, it hurts the eyes. Ironically, these shafts of light look darker than the dark, making the tidal waves go threateningly charcoal. Further out in the bay the contrast is not so stark, and a misty golden glow spills all over the South Bull Wall and envelopes a ferry departing from Dublin Port. Wilted dune grass gives off a sharp, bitter smell, and the evening feels unseasonably mild: you could bet you smelled spring in the air. But hush, it is only a draw, and not the time to let down one's guard. Winter may well have saved its deadliest weapon for last.

The Beauty of the Beast

The rumours start as early as November. *Heard it on the radio the other day. The snow … sub-zero temperatures … the blizzard, the Beast.*[7] It could happen this month, next week, maybe tomorrow. The media keeps us on our toes until eventually the weather gets too warm to be dreaming of a white Christmas.

Apparently, it has not snowed on Christmas Day for a decade now,[8] and the auld Beast only makes an appearance once in a blue moon. But one memorable February morning *the newspapers were right: snow was general all over Ireland.*[9] Of course, it was falling on bogs, glens and rivers, but it was also covering roofs, chimneys, parks and cathedrals – carving out a whole new Dublin.

The ever-busy city centre is for once deserted. The Beast has landed: run for your life, stock up on food, batten down the hatches – most are happy to cosy up at home. Grogan's, Dame Tavern, Keogh's – even the pubs have been surrendered. Like dignified captives, they proudly wear their snowy caps, and their colourful facades daringly flash against the white of the snow. Wooden barrels lined along the walls are all ice, one of them graced with a hastily sculpted snowman, a half-drunk pint of Guinness by his side. He hardly appreciates the joke, looking miserable like a child on the brink of a meltdown. It won't be long, the snowman knows, until the Beast loosens its grip but for the moment its icy clutches reach far and wide. Even the four angels on College Green are powerless against it, or maybe they just did not want a fight. Their trumpets are silent, and their music has frozen: the once bubbly fountain has turned into heavy icicles that weigh down on the angels' wings and pull their trumpets to the ground. They look as if they have been caught out mid-performance: a vigorous flow of melody and inspiration has been mercilessly and unceremoniously stopped, like a life cut short by a freak accident – sudden and desperately irreversible.

The Phoenix Park seems beyond rescue too, so starkly has it changed. The vast green spaces have turned into a tundra where a biting wind blows to its heart's content. It brings with it angry, sharp snowflakes that cut into your face like a razor. The stately Chesterfield Avenue does not look itself, all white and somehow shrunk, running hesitantly into a blurry snowy haze, and its gas lamps look positively

Narnian. There is no sign of timid fauns or dwarfs though. Instead, the seemingly empty fields are dotted with snowmen and snowwomen – chocolate-eyed and carrot-nosed; one of them wearing a bikini – for the craic, of course. Further down, at the foot of the Magazine Fort, Pieter Bruegel's winter landscape has come to life.[10] The wintry slopes and the road beneath are dotted with snow enthusiasts, hurrying up and down the hill like ants. The Beast has caught them unawares – no suitable clothes, no proper gear – but when the long-awaited slide down a snowy slope is at stake, everything goes. Hopelessly wet tracksuit bottoms, DIY snow sliders – Lidl, Tesco, Dunnes bags, whatever takes your fancy; someone has just arrived with a road sign under his arm while three lads at the top of the hill are mounting a car door, getting ready for a mighty swoosh down the slope.

I move across the road (who wants to be run down by a freak car door?) and follow a path to an aspen grove where I spot deer, trying to feed off some dry leaves as their lovely grass is now buried under the snow. Surprisingly, they do not seem to have taken the snow well: the deer look scared and depressed, all flocked together in that little grove, reluctant to roam the park. Perplexed, they watch the fun being had on the slopes with their big sombre eyes, and I feel so sorry I have no food to cheer them up. Isn't it always like that: some having fun while others are ever so sad, perhaps longing to but unable to escape the gloom they find themselves in.

The evening comes, and the snow is falling, *falling faintly through the universe and faintly falling, upon all* those going to sleep and those fallen asleep long ago.[11] The second day of the Beast dawns: the snow is falling. It has got deeper and softer, coming closer and closer to the door. It feels it could snow forever, and not a single person on earth would have the power to stop it. And even if they did, would they willingly use it against the mesmerising beauty of snow? Its advance is so subtle, its fall so gentle, its depth so deceptively sweet. It would

bury you deep, muting all sounds, all worries, all feelings. It would stall your hamster wheel and blow snowdrifts to shield you from the everyday. It would clear space for reflection. Watch its enthralling dance: whirly and confusing during the day and positively magical in the orangey light of streetlamps in the evening. Snowflakes make light of it all: forgive, forget, look kindly on those around you, drop all your grudges, come fly with us – if only for tonight.

Indeed, the following morning, change is in the air. It is March after all, and the Beast must retreat. Dublin is melting away, all too quickly going back to its more normal, grey and damp self. The snow wonderland is but a memory now, growing paler and paler with every minute: a fleeting kiss, a speck on the horizon, a happy dream you have reluctantly woken up from.

Little did we know that there would be a March soon when a different kind of beast would come. *Only a bad dream*, we will shrug it off first, but with time will realise that we cannot wake up, however much we may want to.

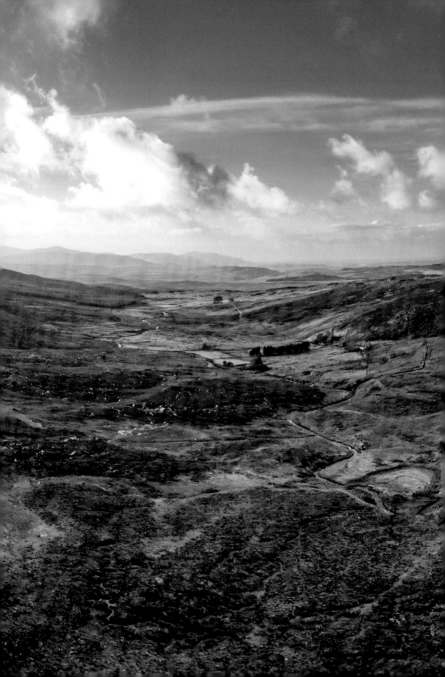

PART 5

IN THESE
STRANGE TIMES

A CROSSING POINT
ATHLONE

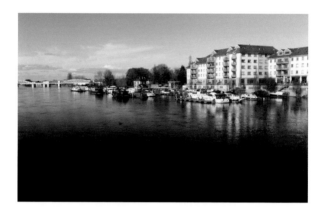

East–West, East–West, East–West – Athlone is tick-tocking across the Shannon as usual. The river is all a-sparkle with that vigorous early-spring madness. It leaves the city behind and hurries downstream, ready to sweep everything away in the name of spring. Flooded meadows, triumphantly blue sky, biting wind, the excitement of the first outdoor lunch. February is not over yet but that brightness over the vast expanse of the Shannon has broken the ice – not as literally as it might have done in colder climes but still no less effectively. It has brought that longed-for promise of life coming back, of victory, confidence and inspiration. The boats bobbing on the river, still anchored but already itching to float away, are firing up my own travel plans. I watch a train creep over the railway bridge and think of all the trips I will go on this year.

Later, I would often think back to that cool, bright late February afternoon when life was bubbling over the edge, and the world was

full of certainty and hope, heading at full steam across the Shannon. Before it braked, it shook and lurched – forward, sideways. We groped for handrails, clutched onto our seats, stood with our legs wide apart, desperately trying to keep our balance on the floor that was slipping from under our feet.

TEMPEST
GAOTH DOBHAIR

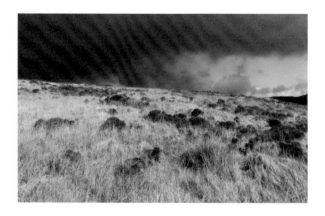

A s Shakespeare aptly noted, the things *we know not of, puzzle the will* and scare us. In a clumsy attempt to outrun the incomprehensible shadow gobbling up the island, I made for *the undiscover'd country* of Donegal, *from whose bourn*[1] I did hope to return, though preferably with a clearer head and a pacified heart.

We read in the Bible that God spent six days creating the world (how long these were is quite another matter). And he rested on the seventh day. Certain enthusiasts like to say it was Donegal he picked for his retreat, so beautifully it had turned out. There is indeed a primal aura about Donegal's landscape. The bare, moon-like Derryveagh Mountains, as if freshly emerged from under a glacier, offer a glimpse into what the newly born Earth might have looked like. Old, wise, their memory going back millions of years, they must have a remedy – something painstakingly simple that will calm our

frenzy and reveal that all of this is no more than an unfortunate misunderstanding.

I throw open the window and look into the night sky, asking for answers – and for a bit of sparkle, in the midst of the impending gloom. The sky is clear, sprinkled with myriads of stars, bright and twinkling, as if trying to cheer us up, winking at us – you will be alright, take courage. I have always been suspicious of stars though, and as I look at them more closely now – cold and twinkling – I am not sure whether it is friendly winking they are doing, or are they smiling viciously, laughing at our panic, safe in the knowledge that they are millions of miles and years away from all our troubles.

So I turn back to earth and peer into the depths of Lough Veagh, in the hope of finding in there something more sinister than the sudden threat we are all facing – no doubt a peculiar way of looking for consolation. As the wind picks up and stirs the black waters of Lough Veagh, crests begin to wrinkle its surface, the disturbed water now revealing the ancient darkness that rests in the depths of the lough. The waves grow rebellious, troubled by the limits the lake sets for them. They furiously splash against the shore, angry at their helplessness. They threaten to pour out and take a proper hold of the valley; if they had their way, they would be crushing against the walls of Glenveagh Castle, eager to drive any human life out of it and have the place to themselves. One leg in the Ice Age, Lough Veagh seems forever unsettled, unable to forget the past and reluctant to accept the present. Unbalanced, prone to change, confused by its own existence, it can hardly offer much consolation to anyone else.

Having failed to drown the looming danger in the lough, I look to displace it, clutching at familiar anchors: streams, bogs, waterfalls. The water is as clear as ever, and the waterfall in Dunlewey is burbling away; the same old tracks run through the bog and further up Errigal's slope. The mountain itself is asleep under a fresh fluffy cloud, not in the least disturbed by human commotion. *Er-regal* – imposing and

overhanging, it greets travellers and immediately lets them know who is in charge. Houses at the foot of the mountain look safe and content under its shadow, like chicks, happily crowding under their mother's wing. I rush towards the summit, trying to oust worry with muscle work. The climb is deceptively easy, but an icy, bitter wind soon bars the way. I lose heart and cling to the nearest crag for support. Where is that homey feeling gone? Errigal is all a-bristle, as if gearing up to face an invisible enemy, up here, on the summit, away from the little cottages down below.

Further unsettled rather than comforted, I descend into the magical valley of the Poisoned Glen, hoping for a miraculous antidote. The abandoned church keeps itself to itself, as if secretly embarrassed for being overdressed for the wild glen that surrounds it. The church is all elegance and composure, like a neat young lady at a Sunday service in one of those pretty English villages. Its tower boasts a headful of gothic spikes, and the dark pointed arcs of its windows remind one of an eye, skilfully highlighted with a sharp eyeliner. It has mastered a poker face so well, it hardly notices the rain fall freely onto its floor, and the wind swish through its very heart. It will hardly notice any new tribulations either.

I turn to face the road into the mountains – and there it stands, right in front of me, a young red deer, graceful and still, like a creature from another world. It stares in disbelief, lingers for another few seconds, and hops away into the shrubbery. A messenger of the strange times to come? An omen? It feels as if a mysterious and distant trigger has been pulled.

COURAGE
MÁM ÉAN

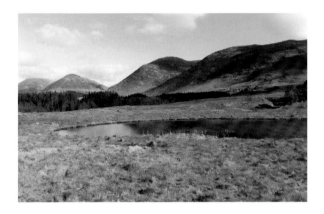

They say Connemara is empty, but is it? It is our hearts that have been emptied out, it is the human world that has gone deserted. Indeed, bitter emptiness has settled where life was bubbling. Scary silence has descended onto the places that relied on noise so much. But Connemara has stayed untouched as its riches are of a different kind: the power of silence, the freedom of solitude. They say it is empty because they know not how fulfilling this emptiness is. It spans the landscape and enters your soul, filling it until there is no space left, so fear eases its grip and trickles out of your heart under the severe gaze of the Maamturks.

Ah that barren road into the hills. I love its lonely bends, its desperate determination, absolute freedom and defiant independence. It does not seek travellers – it is confident enough to exist for its own sake, and for the sheep, of course – they make great use of it for sure. An odd baby

cloud might lazily float across and make for the hills, brushing its cool fluffiness against the coarse slopes. The road leads on though – into the raw beauty of the Maamturks country, to where courage was born.

His slim, gracefully girded figure stands out in the landscape long before the road levels off at the pass. His solitude would break your heart if it were not for the blissful serenity spilt all around him. He strikes that perfect balance between being an integral part of his surroundings and maintaining individuality. His looks are gentle, his form almost feminine, a pensive expression on his face.

A newly ordained bishop – so young, so ambitious – his dream has finally come true. Down below and all around him stretch the lands he had sought so keenly. And now he pauses, taken aback by their *savage beauty.*[2] Don't we all falter when our dreams become dangerously real?

He regards the rough unpretty surface of the rock, the pitch dark waters of a tiny lake (how did it even get up here?), the vast tantalisingly sad boglands finely sliced by lonely roads, and above it all, the expectant and omnipresent silence of the Maamturks: *go on, tell us what you have come here for, we are all ears.*

A sheep is clinging to his leg, hiding its muzzle in his garments, overwhelmed by its master's decision: *are you sure you'll manage? You can turn back, you know. We'll settle in a lush valley, and you'll still be a shepherd, Patrick. Must you really go forth?* But his gaze is fixed on the harsh lands that lie before him. They say courage is not the absence of fear but rather a strong enough will to go ahead regardless. So does the young bishop. Now completely calm, he surveys his chosen lands and even attempts a smile but sudden sadness comes over him – the sadness he cannot explain. Is it the loneliness of the stony road travelling through the pass? Ah no, it is not lonely but free. Is it the malicious darkness of the lake? But its gloom is so dispassionate. Or is it the flowerless bogland down below? But its desolation heals hearts. What it is he cannot say. It

feels far away but utterly bitter – full of injustice, violence, hatred. *To hell or to Connacht*, a distant voice thunders in his ears, the land with *not enough wood to hang a man*,[3] the same voice smirks with disdain. Patrick will be long gone by then but his courage will bring people up here once more, and the unruly veins of Connemara marble will flash their emerald pattern across the altar stone of Carraig an Aifrinn.[4]

The chapel, the statue, the craggy slope – the whole place is so compact you want to hug it, hold it tight and close so that its beauty is forever imprinted on your heart. It is such a comfort to trace the cool emerald veins of the Mass Rock, to press your cheek against the boggy ground; to yearn to hide your face in his garments and forget the pain and worry that the world seems to be drowning in. When all doors are locked, the tiny pass of Mám Éan, hidden in the very depths of the hills, is wide open to those seeking refuge.

Clouds part overhead, revealing a bright blue patch: now it is only a matter of speaking. In these desperate times, I ask for courage – something that Patrick was so good at.

INTO THE WEST
LEENANE

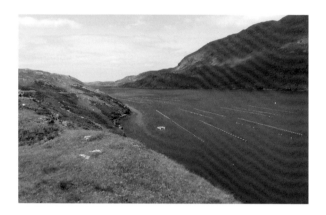

Courage and escape are hardly natural partners but when the whole world turned upside down, they happily joined forces. Beyond the beyonds, as deep into the wild as a public bus can bring you – it takes courage. Away away, west west, to where more ancient powers reign – it does have a ring of escapism about it.

Hidden behind the imposing Bens, beyond glacial lakes and desolate bogland, lies Connemara's emerald heart. As the road turns towards Killary Harbour, the peaks and the bogs step aside to reveal an oasis of every shade of green one can think of. The colour, pristine and intense in the summer, overwhelms and captivates the eye. Leenane Valley feels like an enchanted world of its own, well protected by the Maamturks on one side and the Mweelrea range on the other. A little Gaelic kingdom indeed.

The village of Leenane, squeezed between the hills and the fjord, is unique in that it seems to have accepted the primal power of nature.

Carefully built around every bend of the valley and every crease of the mountains, this work of human hands is happy to play second fiddle to the beauty around it. Seen from above, Leenane reminds me of a tiny bird, lovingly cupped in the hands of a mighty but benevolent giant. What a privilege it is to wake up to this wonderful emerald world; to look at the Maamturks, full of unrivalled wild strength – and see them smile at the little village below and cradle it gently in the crook of their rugged arms.

The proximity to the wild is so striking here that it feels like being in another realm. The hills – huge and silent – preside over the fjord and the valley. They ask nothing and need nothing; they only watch intently with their slow, careful gaze. They lean across the water, coming so close you think you can feel their cool, steady breath. So immediate and inevitable is their wilderness that it momentarily freezes your heart and you almost forget to breathe out. And when you eventually do, it all falls into place. You realise that in Leenane there is no need for arduous hikes and trekking achievements in search of wild beauty – it is here, over your head, at your feet, seeping into your heart. All that remains is to quietly observe this overwhelming beauty, to be present, to be still so that you can become an integral part of it – just like it is enough to simply be in your loved one's presence, when there is no greater happiness than to watch his features, his smile, the look in his eyes, the turn of his neck, the ripple on the inky waters of the fjord, the deep, ancient creases of the hill slopes, the rhythmic lapping of seaweed at the turn of the tide.

❧

Further up the fjord, an old track runs along the southern slope. Wide enough for a regular road at first, it soon reduces to an overgrown path winding its way past abandoned cottages. The fjord, wide and open in its middle part, narrows down, as if squashed by the Mweelrea

peaks that tower intensely over the water. The path is now pushed out to the very edge, running daringly close to the ultimate beauty – a tightly stretched string at the point of breaking. In a desperate spurt, the path scrambles uphill and – it is suddenly over. A gasp of surprise, a lungful of boundless Atlantic, a soul finally set free from illness, pain and death. The Famine Road,[5] built to lead nowhere, eventually dissolves as it meets the mouth of the fjord – that longed-for gateway to absolute freedom.

It is hard to believe this dazzlingly beautiful landscape is so closely bound to misery, heartbreak and death. Killary withstood so much suffering that it could have easily drowned in it – but it did not. It absorbed and processed all human grief, ultimately turning it into peace. Not the idyllic, carefree tranquillity that is so attractive because it is oblivious of turbulence but rather the eternal rest that can only be gained through turmoil. Once stripped of life, Killary miraculously keeps giving, inspires, and heals wounds while carrying its own eternal scars. A host of wildflowers springs up along the Famine Road, and I can't help smiling as I take in the vistas around me. Once a pointless, cruel enterprise, the road is now a solemn monument to those who suffered here. There is hardly a way to right the wrongs of the past. The best we can do now is to actually use the Famine Road: take every step with gratitude and feel no apprehension about relishing the natural beauty it offers.

So wholesome, hard-won and raw that beauty is that no new bleakness can tarnish it. The emerald green of early August has long faded, and the slopes of the Maamturks have turned bronze – in a painfully sharp contrast with unforgiving black waters of Killary. Just as you would recognise the dear features of a loved one despite the cruel marks of age and worries, so my heart went out to the pale, wind-swept and locked-down Leenane, no less majestic than it was in the summer sunshine. Dear Maamturks, I walked their mounds and

hillocks when they were full of life. The darling fjord, I sliced through its waters at sunset while the green giants stood guard. The lovely stream, hurrying through bogland, I drank of its clear turf-coloured water on a hot summer's day. And so we meet again – at the end of this hopeless, ghastly year, with even darker clouds towering before us.

No restaurants, no shops, no cruises; no company, laughter or music down the pub, no fiddle, defiantly carving out a tune through the howling of the wind outside. I look around – the deserted path is winding its way through the hauntingly wilted hills. Is this it? Is it just you and me left here? I climb over the steps at the cattle gate and pause. A reel tune, heartbreaking but clear, is floating through the air. It dances over the hillocks, leaps with the stream, swirls through the twisted branches of a lonely holly. The wind is messing with the iron gate – not whistling, not swishing but producing a distinct melody. In the times of no tunes, Connemara is playing a reel for me.

I listen – and feel tears suddenly well up in my eyes. And then I smile. We are friends so?

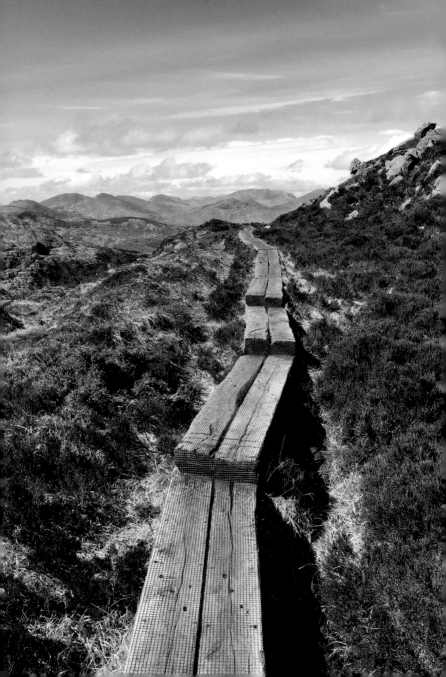

NOTES

PREFACE

1 Martin McDonagh, *The Cripple of Inishmaan* (1996).

2 Emily Brontë, *Wuthering Heights* (1847), London: Collector's Library, 2003, p. 163.

3 Leo Tolstoy, *War and Peace* (1863), New York: Vintage Classics, 2009, Volume 1, Part 3, Chapter XVI, p. 281.

PART 1: THE FLOWERS AND THE GLORY

1 Patrick's Rock (Irish).

2 Inspired by Eoghan Rua Ó Súilleabháin's poem, 'Do threascair an saol'.

3 Ibid.

4 Lia Fáil (Stone of Destiny) was the coronation stone of the kings of Tara. According to tradition, when a true king placed a foot on Lia Fáil, it cried out to announce his rightful reign. 'Hill of Tara', *Discover Boyne Valley*, https://www. discoverboynevalley.ie/boyne-valley-drive/heritage-sites/hill-tara; accessed 14 November 2021.

5 Robert Burns, 'My Heart's in the Highlands' (1789).

6 Patrick Pearse, 'The Wayfarer' (1916).

7 WB Yeats, 'Under Ben Bulben' (1938).

PART 2: THE WILD ATLANTIC SPRAY

1 'The Kingdom' is an informal name for County Kerry.

2 This is a reference to the first survey of Ireland by the British Ordnance Survey, which commenced in 1824. One of its purposes was to establish anglicised versions/spellings of place names in Ireland, many of which were only known in Irish at the time.

3 Béal Inse itself is not in use anymore. The official Irish name for Valentia is Dairbhre.

4 Which translates from Irish as 'Little Skellig'.

5 This island, due to its characteristic shape, is popularly known as An Fear Marbh (the dead man) in Irish or The Sleeping Giant in English.

6 'The White Beach' (Irish). A sandy beach that faces the mainland.

7 A reference to the legendary Tír na nÓg (The Land of Eternal Youth).

8 Literally, 'Enda's Church' (Irish).

9 Literally, 'Enda's family' (Irish).

10 Oscar Wilde, 'Requiescat' (1881).

11 Toilet (Irish).

12 These lines, as quoted, come from the third film in *The Lord of the Rings* trilogy, *The Return of the King*, 2003. A similarly

worded description of the world beyond death can be found in the novel itself; however, Gandalf does not deliver it but it forms part of Frodo's dream in Tom Bombadil's house. The description is later repeated when Frodo departs Middle-earth at the end of the novel.

PART 3: OF MYTHS AND MAGIC

1 A reference to JRR Tolkien's visits to Galway and the Burren in the 1950s when he was an external examiner to the English department of NUI Galway.
2 The Irish for 'doves' hole'.
3 CS Lewis, *On Stories* (1947), https://gutenberg.ca/ebooks/lewiscs-onstories/lewiscs-onstories-00-h.html; accessed 14 November 2021: CS Lewis, *On Stories: And Other Essays on Literature*, New York: Harcourt Inc., 1982, p. 8.
4 William Shakespeare, *Hamlet*, Act I, Scene V.
5 God's tears (Irish).
6 Dante Alighieri, Inferno, Canto 1, The Literature Network, http://www.online-literature.com/dante/inferno/1/; accessed 14 November 2021.
7 'Hymn of the Cherubim' as sung at the Eastern Orthodox liturgy.
8 A paraphrase of Emily Brontë, *Wuthering Heights* (1847), London: Collector's Library, 2003, p. 48.

9 John J. Kilbane's son, Johnny, was a world-famous Irish-American boxer (1889–1957).

PART 4: A PORTRAIT OF DUBLIN AS A GRAND CITY

1 Scoil Éanna was founded in 1908. Starting from 1910 it was housed at the Hermitage in St Enda's Park. The school curriculum was conducted entirely through the medium of the Irish language. Not unusual now but a rare, almost unheard of thing in the early years of the twentieth century.
2 Patrick Pearse, 'The Wayfarer' (1916).
3 *The Lord of the Rings: The Return of the King* (2003).
4 Loneliness, solitude; longing or pining after someone or something (Irish).
5 Áras an Uachtaráin, residence of the president of Ireland, situated in the Phoenix Park.
6 An ancient Celtic festival associated with the start of winter. These days it has been recast for international use as Halloween.
7 Reference to 'The Beast from the East', the name given to a snowstorm that hit Ireland in late February–early March 2018.
8 According to *Snowfall in Ireland* (2012), a publication by Met Éireann, the last white Christmas occurred in 2010.

9 James Joyce, 'The Dead', *Dubliners* (1914), London: Vintage Classics, 2012, p. 203.

10 Pieter Bruegel the Elder is a sixteenth-century artist of the Flemish and Dutch Renaissance. His most famous paintings include landscapes and peasant scenes.

11 James Joyce, 'The Dead', *Dubliners* (1914), London: Vintage Classics, 2012, p. 204. The text in italics is a direct quote and the end of the sentence is a paraphrase of the closing sentence of 'The Dead'.

PART 5: IN THESE STRANGE TIMES

1 William Shakespeare, *Hamlet*, Act III, Scene I.

2 As per a quote from Oscar Wilde, who coined this phrase.

3 These two statements are attributed to Oliver Cromwell, who lead a cruel plantation policy in Ireland in the early 1650s.

4 Translates from Irish as 'Mass Rock', a stone that was used as an altar for celebrating Mass at the pass of Mám Éan during the time of the Penal Laws when conducting or attending a Mass was illegal.

5 The road along the southern slope of Killary Fjord is one of the so-called relief roads that were built around the time of the Great Famine. This particular road was built slightly later, in 1856. The starving poor were given work as builders so that they could earn the minimum wage to buy food. The work involved hard physical labour, which sometimes proved fatal to the already weak and sick labourers.